IMAGES
of America

GERMAN
NEW YORK CITY

IMAGES
of America

GERMAN
NEW YORK CITY

Richard Panchyk

ARCADIA
PUBLISHING

Copyright © 2008 by Richard Panchyk
ISBN 978-0-7385-5680-2

Published by Arcadia Publishing
Charleston SC, Chicago IL, Portsmouth NH, San Francisco CA

Printed in the United States of America

Library of Congress Catalog Card Number: 2008921570

For all general information contact Arcadia Publishing at:
Telephone 843-853-2070
Fax 843-853-0044
E-mail sales@arcadiapublishing.com
For customer service and orders:
Toll-Free 1-888-313-2665

Visit us on the Internet at www.arcadiapublishing.com

For Peter Prommersberger

CONTENTS

ACKNOWLEDGMENTS

I first want to thank all those people who have provided me with photographs for this book, notably Richard Albrecht, Robert Albrecht, Jan Kelsey, Barbara Penschow, Caren Prommersberger, Jean Prommersberger, Peter Prommersberger, Joan Quinn, Jeremy Schaller, Peter Schaller, Eleanor Sullivan, William R. Voigt, Peter Wieschenberg, and Anita Wunsch. I also want to thank those who have aided my research on Germans in New York City over the past 20 years: Margaret Wagner, Eleanor Panchyk, Don Albrecht, Marilyn Rudden, Al Pedemonti, Victoria Wirth, and Louise Penschow. I want to extend special thanks to my excellent editor Erin Vosgien and to my wife and children for their support. I would also like to give credit to the Library of Congress Prints and Photographs Division, whose images appear on pages 10, 13 (top), 16 (bottom), 28 (bottom), 29, 30, 32 (top), 33 (top), 36 (bottom), 37 (bottom), 39, 46 (top), 51 (bottom), 55, 58, 59, 60 (top), 63–66, 68, 70 (bottom), 71 (bottom), 74, 90, 104 (top), 111 (top), 115 (bottom), 118 (top), and 119. Credit also goes to the National Park Service for the image on page 16 (top).

INTRODUCTION

During the 17th and 18th centuries, there were relatively few Germans in New York City, yet Germans still made their mark. One of the earliest Germans of note was the infamous Jacob Leisler, who took over the governorship of New York by force (an event called Leisler's Rebellion) during a turbulent time in the colony's history and ruled from 1689 to 1691. Leisler was found guilty of treason and hanged in 1691. Another early German of note was John Peter Zenger, publisher of a 1730s newspaper called the *New-York Weekly Journal*. Zenger was tried for libel against government officials but found not guilty by the jury, in what was one of the nation's first victories for free speech. Still another early prominent German was John Jacob Astor, who became a wealthy fur trader and founded a dynasty.

The majority of Germans immigrants who came to the United States during the 17th and 18th centuries were farmers who settled in places such as Pennsylvania, Virginia, or North Carolina. Yet that trend changed quickly during the 19th century. In fact, by the third quarter of the 19th century, the German community in New York City was so extensive that the metropolis had the third-largest German-born population of any city in the world. Around this time, the percentage of Americans with German blood began to catch up to those with English blood. By 1900, there were over six million Americans who had both parents born in Germany.

New York City of the 19th century was a dynamic and exciting place, growing by thousands of people every month. There was still undeveloped land to be had, and opportunity beckoned. For German immigrants, the city represented a chance at a new life and hopefully an escape from the poverty and hopelessness that life in Germany promised. Although the streets were not paved with gold, a hardworking German immigrant could make a decent living and provide a good life for his family.

As the German community in New York City grew, German businesses thrived, not only in the heavily German neighborhoods but all over the vast city. It is not surprising, therefore, that Germans have had a marked influence upon every aspect of life in New York City. And although they celebrated their cultural heritage through their food, language, and traditions, they were also quick to recognize the need to become Americans and New Yorkers. The generation of New Yorkers born to German immigrants became completely Americanized, yet many of them spoke German and still clung to some of their parents' German traditions.

For thousands of German American New Yorkers, military service during World War II was the first substantial time they spent away from New York City. After the war, most of these returning veterans decided to move away from the German neighborhoods and into the suburbs. Although the peak of German culture in New York City occurred during the late 19th and early 20th centuries, countless thousands of New Yorkers still celebrate their German heritage today.

This book is meant to be both a celebration and remembrance of German New York City, a tour through the German American experience told in pictures.

In chapter 1, I discuss immigration, then move on in chapter 2 to talk about the places of German New York City, including neighborhoods and businesses. This is followed in chapter 3 by a sampling of stories about some of the German American people of New York, both ordinary and famous. In chapter 4, I move to education and religion, and then in chapter 5, I talk about German cuisine. In the final chapter, I look at German culture and recreation. Whole volumes could certainly be written on each of these topics, but I have tried to give a sampling of what life was like in German New York City.

One

THE IMMIGRANT EXPERIENCE

The first Germans arrived in New York City hundreds of years ago, but the steady tide of German immigration did not begin in earnest until the 1840s. Famine, poverty, and political strife in their homeland led to the great number of German immigrants to the United States, often topping 100,000 in the years between 1852 and 1892. After 1900, immigration slowed for several reasons, including immigration quotas imposed following World War I. German immigration rose again during the hard times in Europe after World War II but never again reached its former heights. The hardworking immigrant generation made the best of its new life and tried to set a good example for its children.

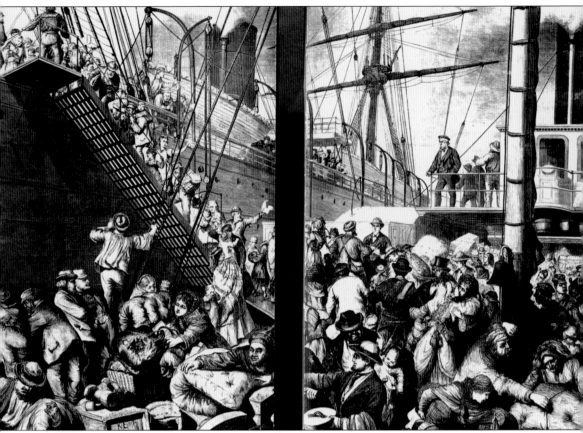

The promise of a better life lured millions of Germans to the United States. On the ships that transported them to the New World, and again at Ellis Island, German immigrants were thrown together with immigrants from all over Germany, as well as from many other countries. It was an early taste of what their lives would be like in New York City. For many, who had never left Germany before, these other foreigners were more exotic than they could have imagined. This image shows a chaotic scene as German emigrants board a ship bound for New York City in 1874.

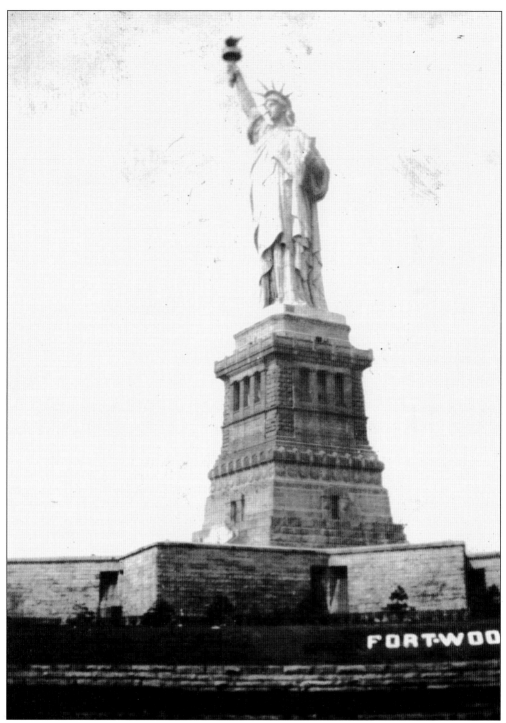

FORT·WOO

From the 1880s and on, the Statue of Liberty, a gift from France to the United States, greeted immigrants as they sailed into the New York harbor. It was a fondly remembered sight by many. This photograph was taken in 1928 by a recently arrived German immigrant, as a remembrance of the majestic sight that greeted him when he first came.

Impfschein.

Von dem unterzeichneten zur Schußpockenimpfung ermächtigten Impfarzte wird hierdurch pflichtgemäß beſcheinigt, daß *Friedrich Wilhelm Voigt*

geboren am ___ 18 5 4 zu *Eitenberg*

den *10ten Juni* 18 5 6 mit Schußpocken geimpft worden und hierauf bei der heute vorgenommenen Unterſuchung mit ächten Schußpocken behaftet geweſen iſt.

Eisenberg im ___ Medizinalbezirke des Herzogthums Sachſen=Altenburg,

den *18 Juni* 18 5 6.

D. Fr. Schaubach
Leagirtsbarzt

Nachruf.

Gedenke mein, Du Theure, die ich liebte,
Wenn Du herab ſiehſt aus dem Himmelszelt.
Es iſt mein Troſt, daß ich Dich nie betrübte
Geliebte, die Du warſt mein Alles auf der Welt.

Wie unerwartet ſchnell haſt Du mich doch ver-
 laſſen,
Wie einſam und allein ſteh' ich nun hier,
Kein einzig's Mal kann ich Dich mehr umfaſſen,
Ach, könnt' ich doch zum Himmel folgen Dir!

Für dieſe Welt biſt Du von mir geſchieden
Und wandelſt jetzt auf Gottes Himmelshöh'n.
Der einz'ge Troſt bleibt noch für mich hienieden:
Daß wir im Himmel uns einſt wiederſehn!
 C. G.

Immigrants to the United States did not bring very much with them, and after several years in New York, little was likely to be left of what the immigrants originally transported across the Atlantic. One of the surviving items brought from Thuringia to New York City by William Friedrich Voigt in the early 1880s was his folded up *impfschein*, or immunization certificate against smallpox, dated 1856, when he was two years old. Another item he brought over was a Lutheran prayer book that he received as a teenager in Eisenberg, dated 1869. Tucked inside the treasured book was this inspirational religious poem carefully cut out of an 1880 German newspaper.

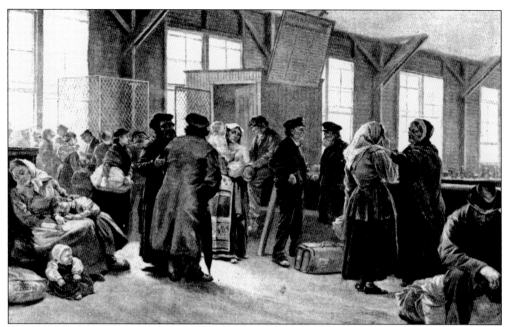

Thousands of German immigrants were detained upon their arrival in New York City. Those who were ill with contagious diseases or had become ill on the trip were hospitalized; some were eventually sent back to Germany. Others were detained if they were "likely public charges," in other words, a woman and child arriving here with no means of support who would become charity cases. These too were sent back to Germany unless someone could be found to vouch for them.

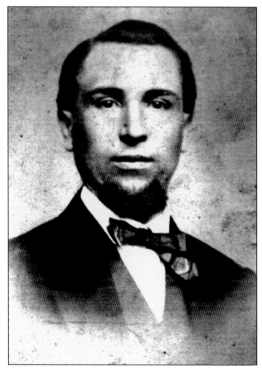

Single parents, whose spouses had died in Germany, led some immigrant families. Johann Joachim Heinrich Conrad Penschow, born 1835, died in 1874. His wife, Katharine, and son Emil Rudolph (born in 1871) came to New York City in 1884. Not long after they arrived, the family had copies made of this old photograph of their dear departed patriarch, at the Theodore Dimmers photograph studio in the downtown German neighborhood of Kleindeutschland, 105 Fourth Avenue, between 11th and 12th Streets.

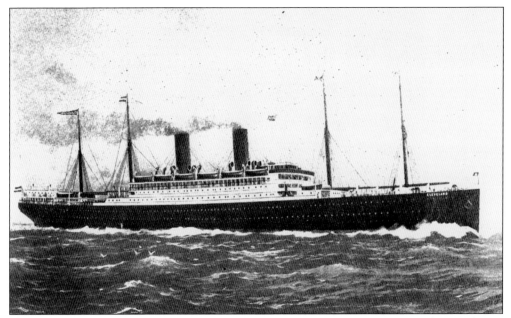

There were several steamer lines that brought German immigrants to New York City during the 19th and 20th centuries. One of them was the Hamburg-Amerika. Each steamer company owned a number of different ships that were plying the Atlantic route at any one time. The most common German ports of departure were Hamburg and Bremen; ships sometimes then stopped in England on the way to America. The German departure points were also the closest place for people from many other countries besides Germany (Poland, Austria, Russia, for example), many of whom faced a days-long overland journey before reaching their port of departure. This photograph shows the *Cleveland* of the Hamburg-Amerika Line in the early 20th century.

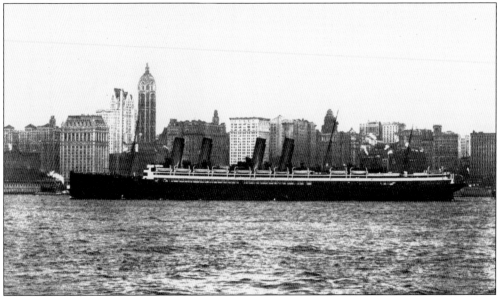

Another steamer company that transported countless thousands of Germans to New York City was Norddeutscher Lloyd Bremen. Shown here is one of that company's ships, the *Crown Princess Cecilie*, in the early 20th century.

Aid was available for German immigrants to New York City. For example, an organization called the Deutsche Geselleschaft was founded in 1784. The two-sided advertisement card shown on this page is for the Deutsche Lutherische Emigrantenhaus, founded in 1873. Run by a missionary named Doering, it was located on State Street in downtown Manhattan. It offered low-priced food and lodging, as well as free information and other assistance. In its first 10 years of existence, the Deutsche Lutherische Emigrantenhaus provided much-needed aid to nearly 70,000 German immigrants.

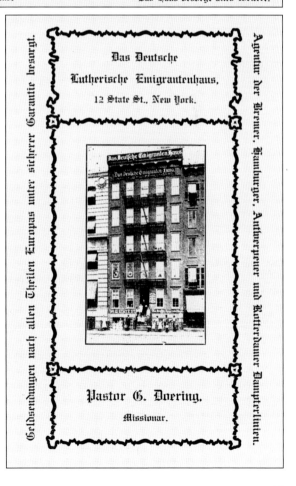

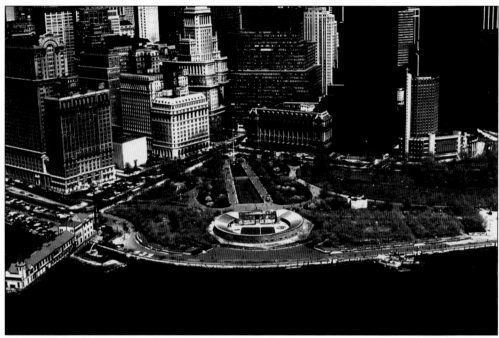

Located at Battery Park on the southernmost tip of Manhattan Island, Castle Garden was the precursor to Ellis Island for those immigrants who arrived in New York between 1855 and 1890. The building was later converted into the New York Aquarium. Today what is left of the complex is preserved and is known as the Castle Clinton National Monument. This photograph of the site dates to the 1960s.

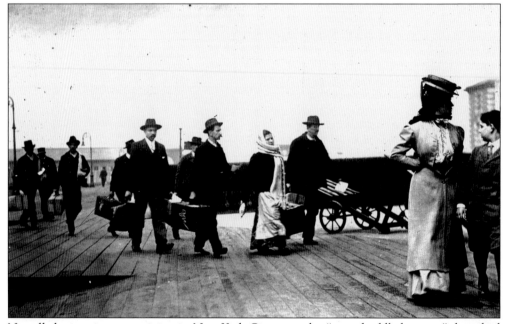

Not all the immigrants arriving in New York City were the "poor, huddled masses" described in the famous poem by Emma Lazarus, as appears evident from this undated photograph of immigrants arriving at Ellis Island (probably around 1910).

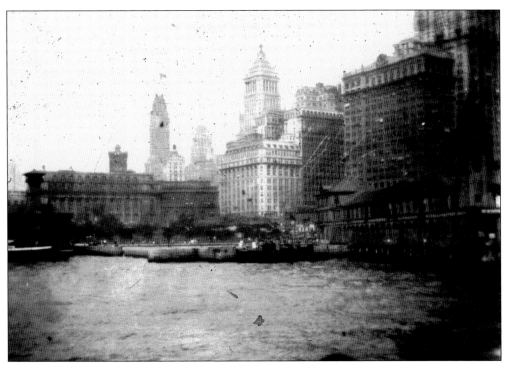

German immigrants arriving in New York City would have had quite a view of the downtown skyline from the water as they arrived from Ellis Island to Manhattan. Even if they came from the biggest cities in Germany, such as Berlin or Hamburg, they would still have been impressed with the size and number of Manhattan's tall, massive buildings. These two images of the New York City skyline as seen from the water were taken by a German American about 1915 and were recently rediscovered in a cache of old film negatives.

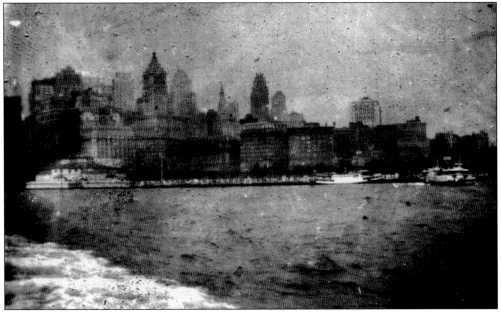

BIRTHS.
Reported in OCTOBER, 1888.

NAME	Date of Birth	No. of Certificate	NAME	Date of Birth	No. of Certificate
Armand, female	May 25	28674	Augstein, Peter P.	Oct. 16	29837
Admec, Ouie	June 1	28675	Axt, female	" 17	29120
Autect, Henry	July 26	29686	Abrams, Clarence W.	" 18	29121
Asplund, Clara	Aug. 17	27258	Anderson, George	" 18	29078
Adams, Florence	Aug. 27	27671	Ajello, Nicola	" 20	29879
Antony, John H.	Sept. 13	27543	Aronsohn, Celie	" 21	29261
Anderigg, Paul E.	" 21	27544	Alsberg, Estella	" 22	29880
Ackermann, Grace D.	" 25	27259	Albert, Eddie	" 2	28015
Alperowitz, Leah	" 26	27379	Alfeld, Charles	" 2	28016
Allen, Florence F.	" 29	27260	Arenhold, Constanze K.	" 3	27801
Alt, Friedrich J.	" 20	28014	Anderson, Harold H.	" 5	27802
Arns, Ema	" 30	27674	Adler, Martha	" 5	27927
Albrecht, Ernest J.	" 10	28355	Ahnuty, Alice	" 8	27808
Angrish, Pauline	" 21	27672	Allen, James	" 9	28221
Angrish, Yutrich	" 21	27673	Andres, Augustus	" 13	28222
Alexander, female	Oct. 2	27261	Barker, female	March 13	29690
Andreas, Mabel	" 10	29839	Bresnan, male	" 18	28676
Auerbach, Flora	" 11	29687	Burel, female	May 7	28677
Apel, Maria	" 18	29588	Boyd, female	June 8	28678
Arnold, Charles E.	" 16	29688	Breslin, male	" 19	28679
Auslender, David	" 20	29840	Bohne, Eitha	Aug. 12	29262
Amren, Katie	" 20	29589	Brosowski, Hyman	" 21	29275
Adler, female	" 22	30103	Blumart, Tresa	" 28	28585
Arthur, Bruce	" 24	29841	Baker, Mary M.	" 29	29263
Aprel, Elka	" 25	30104	Brush, male	" 30	29264
Adrian, Gertrude T.	" 25	29689	Brogan, Florence	" 10	27804
Aaronowitz, female	" 25	29938	Brittain, Margaret	" 16	27545
Aaronowsky, male	" 26	99959	Remak, Isak	Sept. 3	28358
Aiken, John R.	" 27	29960	Billig, Sam	" 12	28825
Austin, Edward F.	" 5	28582	Burns, John S.	" 16	28739
Audriejewska, Marza	" 7	28356	Biener, Rosie	" 25	28826
Asnes, Julius	" 7	28488	Bisland, Henrietta	" 1	29497
Adamec, Edward	" 7	28489	Boyle, mlea	" 26	29590
Anderson, Mabel	" 9	28584	Baggin, Frank	" 2	27262
Albus, John	" 9	28738	Baum, James E.	" 15	27263
Altmayer, Marvin C.	" 9	28922	Bressler, Francis	" 15	27264
vres, Mary E.	" 10	28945	Brady, Margaret	" 16	27265
rmstrong, Mary	" 12	28357	Brumanstein, Jack	" 18	27266
Adelgeis, Henry W. A.	" 12	28490	Broader, male	" 21	27124
Adams, male	" 12	28823	Breidenbach, Mary	" 22	27132
Adam, William P.	" 12	28824	Brady, James D.	" 22	27126
Armstrong, Thomas	" 13	28943	Roller, George W.	" 23	27131
Ahearn, female	" 13	29259	Bayer, Elisabeth C.	" 23	27129
Aber, Abram	" 14	29260	Bruggemann, Mary A.	" 23	27130
Ackermann, Barbara	" 15	28944	Baer,, Carl F.	" 24	27478

Many of the German immigrants who arrived during the 1870s and were young, single men and women, perhaps in the range of 16 to 22 years old, or young couples with one or two small children in tow. As these immigrants settled in New York City, they began to expand their families. Thousands of New York–born German Americans had siblings born in Germany. As reflected in this list of Manhattan births in the month of October 1888, children with German surnames born that month included Adelgeis, Albrecht, Anderigg, Augstein, Baer, Breidenbach, and Bruggemann.

It was commonplace for German immigrants to send money or other items to the relatives they left behind. This 1920 export company advertisement offers package deals for shipment to Germany and Austria. Such items were especially welcomed during the difficult years following World War I. For $40 (a great deal of money at the time), one could send relatives sugar, cocoa, Crisco, and olive oil, among other items.

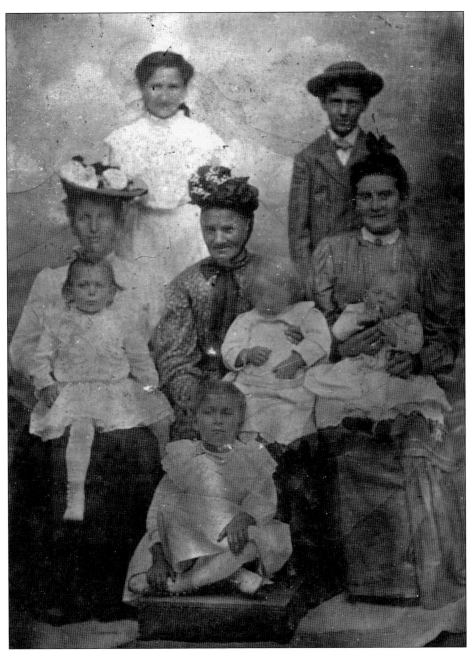

Austrians and German Swiss also came to New York City by the thousands (as well as Germans who had immigrated to Russia during the 18th century). In this tintype photograph from 1905, Maria Pfister Ryf (born in the 1830s) poses with members of her family around 1905. She and her family arrived during the late 1880s from Bannwyl, Canton Bern, Switzerland. Her eldest son, John Ryf, had arrived a few years earlier, in 1884, and settled on East 58th Street in Manhattan and made a living as a shoemaker. The rest of the Ryf family moved to Queens County, just on what would become the Queens County/Nassau County border. In 1922, at the age of 60, John Ryf applied to the government for a passport. He intended to spend six months in Europe, visiting Germany, Switzerland, and other countries.

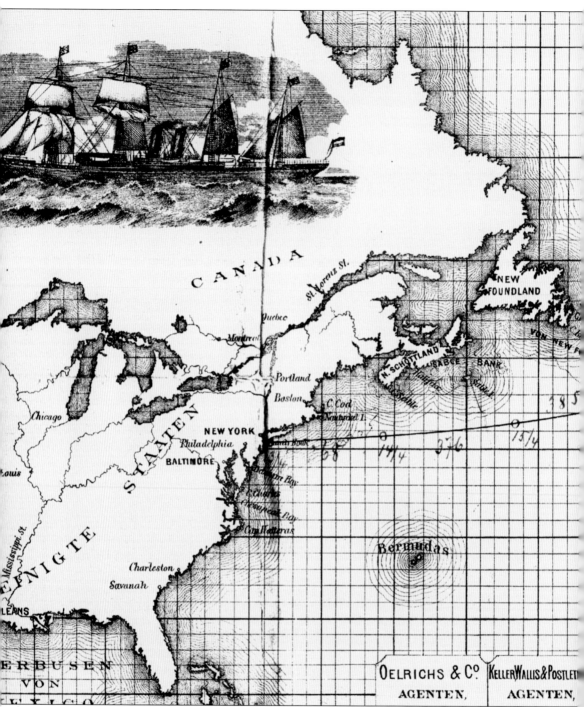

Some German immigrants wanted nothing more to do with their homeland after making the journey to New York City, preferring to make a clean break. Many others left behind dozens of family members and friends, and so wrote home often. There were also a few immigrants who did not find America to their liking and returned to Germany for good. Others still, like Pauline Voigt, formerly of Eisenberg (Thuringia), liked New York but missed the old country. Voigt had

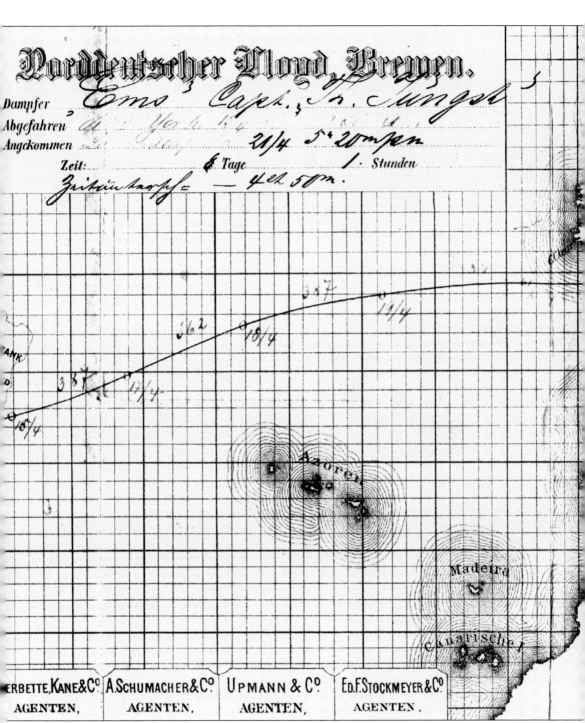

enough money after a few years in New York City to make a trip back to the old country to visit family. She made several trips to Germany, sometimes bringing one of her children with her. She used this map, given out by the Norddeutscher Lloyd Bremen shipping company, to trace her eight-day voyage back to Europe in 1887, marking how far the ship traveled each day. She kept it as a keepsake of her voyage, and it was passed on to her daughter and granddaughter.

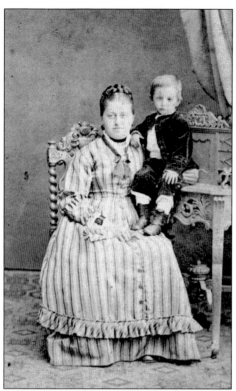

On one of her return trips to Eisenberg during the 1880s, Pauline Voigt paid a visit to the Julius Dorstling photograph studio with one of her young children and posed for the camera, perhaps intending to leave some copies of the photograph behind for her relatives there. Because such a trip to the homeland took at least eight days each direction, in addition to overland travel from the German port, it would certainly be worthwhile to stay in Germany for at least a few weeks, making the overall trip last about two months. The immigrant generation was more likely to make such trips than its grown offspring, who had weaker connections to the homeland.

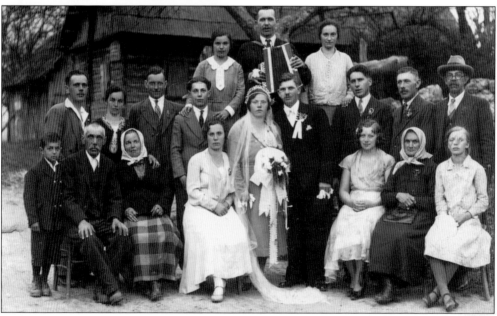

During the mid-20th century, after World War II displaced them, thousands of ethnic German immigrants arrived from the area of the former Yugoslavia known as Gottschee. Most of these immigrants settled in Queens, especially Ridgewood and Middle Village. In this photograph from the 1930s, a wedding celebration takes place in a Gottschee village for the newly married Rudolph and Julia Jonke, who left their home for New York City in 1950.

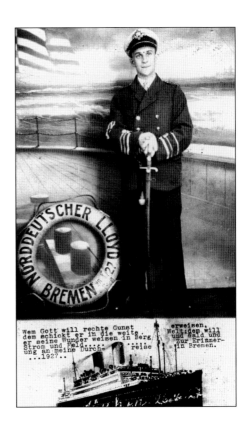

Carl Prommersberger (right), who left Germany in 1927, and Babette Kunsteiger (at top left of the photograph below), who left Germany in 1928, are shown on their respective journeys to America. For many German immigrants, a sense of finality only sank in once they were sailing across the vast and awesome expanse of the Atlantic Ocean. After thinking about leaving and saving up money for the trip for what was sometimes years, they were finally on their way. During the 20th century, immigrants of some means might have had a camera to take photographs documenting their voyage or perhaps paid for a posed photograph on the ship.

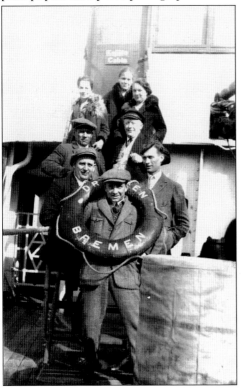

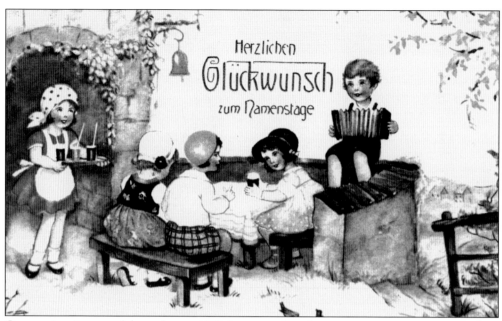

German immigrants of the early to mid-20th century found it easier to communicate with their overseas relatives than had the generation arriving during the 19th century. The advent of the telephone combined with speedier (although still slow) international mail allowed New York Germans to remain in better touch with their friends and relatives. Young Hanns-Peter, born just two years after his parents immigrated to New York, received numerous cards and letters from his grandparents, uncles, and other relatives in Nurnberg. These postcards, from 1931, offer the young boy good luck on his name day. Incidentally German companies monopolized the printing of American postal view cards, including numerous New York City views, in the early 20th century. They possessed technological and production capabilities that made it difficult for American firms to compete.

Modern-day descendants of German immigrants to New York City are sometimes so overwhelmed by curiosity that they make the trip back to their ancestral village to find out more about their roots. The availability of vital records from many German towns and villages has made German genealogy quite fruitful. The author is seen here in Erbach, Odenwald, in 1997. He stands before a 200-year-old half-timber house belonging to the Heilmann family, cousins of his ancestors.

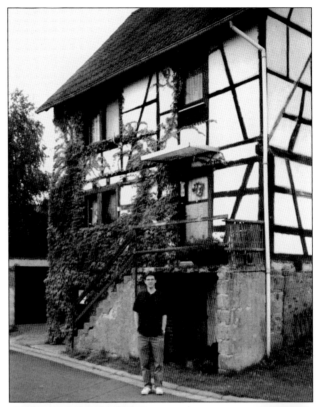

This is the castle at Erbach, Odenwald (near Heidelberg), as it appeared in 1997. Many Germans lived in close proximity to a castle, and some even served nobility in the old country, either as maids and servants, hunters, or simply tenant farmers on land owned by counts and dukes.

German immigration to New York City did not end with World War II. In fact, thousands of Germans, including some who had been displaced or otherwise suffered during the war, arrived in the years following 1945. German immigration reached a 20th-century high in 1952 when it hit 104,000. Peter Wieschenberg left the town of Celle for New York City in 1959, following a brother who had left two years earlier. Wieschenberg found an apartment in Elmhurst, Queens, and then moved to Jackson Heights, where he shared an apartment with another German immigrant. He is pictured here in 1960.

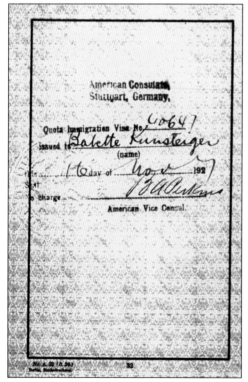

Germans wishing to emigrate in the 20th century had to deal with new American immigration quotas. From 1924 to 1927, the German immigration quota was about 51,000, based on 2 percent of the German population in the United States at the time of the 1890 census. In 1927, the number was readjusted based on the U.S. population of different ethnic groups in the 1920 census. Shown here is Babette Kunsteiger's German passport, stamped on the last page by the American consulate, showing her to be overall visa number 60647 of the year 1927.

Two

PLACES AND BUSINESSES

Early German immigrants lived on Manhattan's Lower East Side. As the city expanded northward over the course of the 19th century, many German immigrants moved north as well. The Upper East Side neighborhood known as Yorkville gained popularity with Germans during the 1870s and 1880s. Although the true heart of Yorkville was the blocks immediately around 86th Street between First and Second Avenues, in actuality, the neighborhood spanned from about 76th Street to 96th Street, from about Lexington Avenue to the East River. There they coexisted with Polish, Russians, Hungarians, and other eastern Europeans, but the neighborhood was predominantly German. Kleindeutschland remained a German stronghold until 1904, when a deadly fire on a ship carrying Germans from Kleindeutschland resulted in much of that neighborhood's remaining German population moving to Yorkville.

Although some German families remained at one address for years, many others moved from place to place as their families grew and their circumstances changed; some needed a cheaper apartment as their employment fortunes declined, while others sought better lodgings as they made more money.

As the 20th century progressed, thousands of German Americans moved to the other boroughs, to neighborhoods such as Morrisania, Ridgewood, Williamsburg, Astoria, Glendale, and Middle Village. Although those neighborhoods in particular had a heavy concentration of Germans, there was no neighborhood in the entire city that did not attract some German families. By the early 20th century, thriving German-owned businesses were spread all over the city.

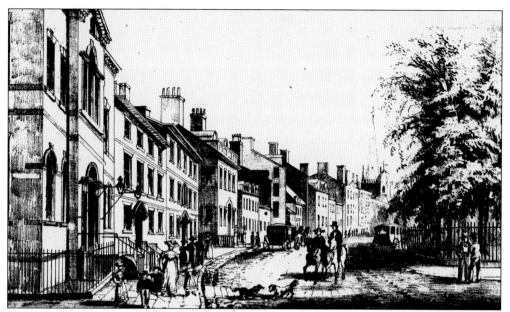

Shown here is Broadway at Bowling Green in 1828. Between 1821 and 1830, only 6,761 German immigrants arrived in the United States, compared to 75,803 from the United Kingdom. The small, quiet New York City that the early German immigrants came to was a far cry from the noisy and bustling city of the later 19th century. The population of the city was just 202,589 in 1830, but by 1880 it had grown to 1,206,299.

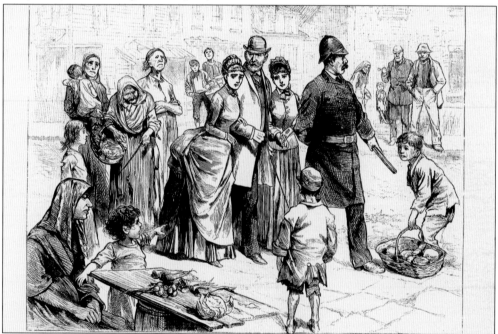

The Five Points was a notorious Lower East Side 19th-century New York City neighborhood. Although it was predominantly Irish, many Germans lived in this neighborhood before they moved to better lodgings uptown in the second half of the 19th century and first decades of the 20th century. This 1860 illustration shows a policeman trying to keep the peace.

This 1874 map of New York City was drawn by Johann Bachmann and printed by Schlegel of William Street. In 1874 alone, 87,291 Germans immigrated to the United States, with many thousands of them choosing to remain in New York City.

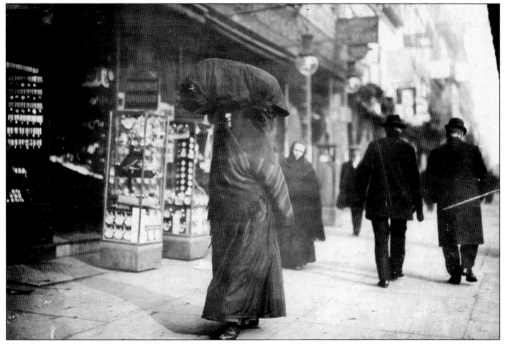

The Bowery, from the Dutch word *bowerie* (meaning farm) was another locale populated by Germans in the early to mid-19th century. Similar to other Lower East Side neighborhoods, Germans migrated uptown from here toward the end of the 19th century. This image of everyday life on the Bowery was taken around the beginning of the 20th century.

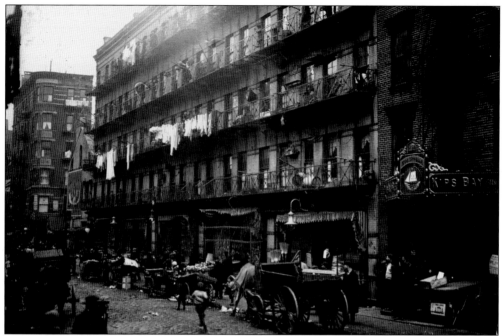

Tenements on the Lower East Side were very overcrowded. One survey made during the early 1890s found 1,400 people in 300 families living in one block. Of those families, 244 were German, 16 Irish, and 11 American-born. Shown here is a row of downtown tenement buildings on Elizabeth Street in 1912.

The German Savings Bank, seen here in 1874, was located at 8th Street and Fourth Avenue, near Union Square. The bank was founded in 1858, and Mayor Daniel F. Tiemann was a charter member. The bank operated out of the Cooper Union Building for a few years, until it moved into its own building. It eventually became a part of the Apple Bank for Savings.

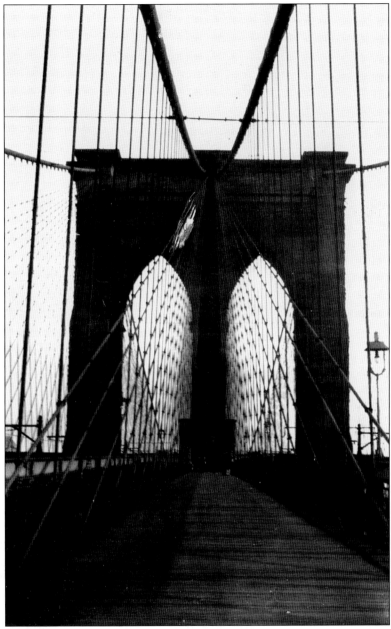

The Brooklyn Bridge was designed by John Augustus Roebling, a German engineer who arrived in the United States in 1831. Roebling first made his mark designing bridges in Pittsburgh and Cincinnati. The Brooklyn Bridge was many years in the making, from planning to completion. Roebling died in 1869 on the bridge site as the result of an accident. His son Col. Washington Augustus Roebling took over the project but was severely injured by the bends while working underwater at the bridge piers. The bridge finally opened in May 1883 to much fanfare. The bridge, the longest suspension bridge in the world when completed, connected Brooklyn with Manhattan. The bridge resulted in continued growth and prosperity on both sides of the East River, and it made travel between the two locations much easier than it had been before, when a ferry trip was the only way. This photograph was taken about 1928.

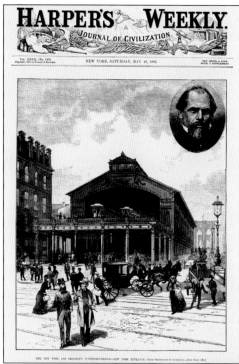

HARPER'S WEEKLY.
JOURNAL OF CIVILIZATION.

Vol. XXVII.—No. 1379. NEW YORK, SATURDAY, MAY 26, 1883. TEN CENTS A COPY.
WITH A SUPPLEMENT.

THE NEW YORK AND BROOKLYN SUSPENSION-BRIDGE—NEW YORK ENTRANCE.—From Photograph by Anthony.—[See Page 326.]

The cover of the *Harper's Weekly* edition of May 26, 1883, celebrates the opening of the Brooklyn Bridge with a detailed image of the New York City entrance to the bridge and an inset engraving of its celebrated German-born engineer, John Augustus Roebling.

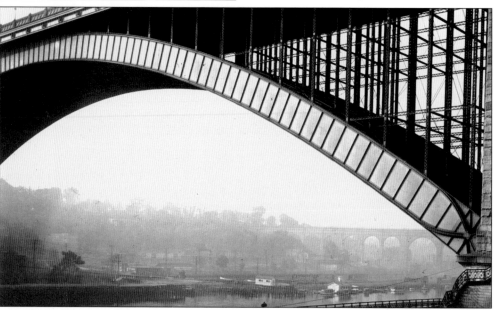

The Washington Bridge is one of the city's oldest bridges. Spanning the Harlem River, it connects Manhattan (West 181st Street) and the Bronx (University Avenue). Built in 1888, the bridge was designed by the German engineers Charles C. Schneider and Wilhelm Hildenbrand. Schneider later became vice president of the American Bridge Company. In 1887, he devised the first method in the United States to evaluate the effect of live loads on a bridge. Hildenbrand, on the other hand, assisted Roebling in the design of the Brooklyn Bridge. This photograph of the Washington Bridge dates to about 1915.

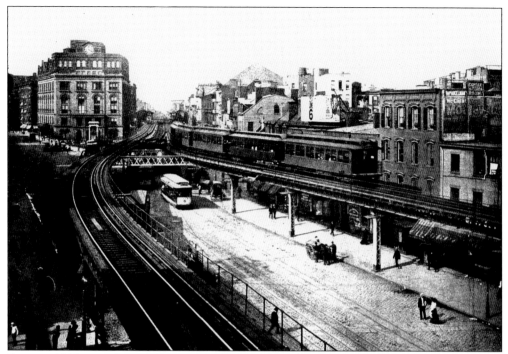

Seen in 1909 near Cooper Square, the Bowery was also the route of the elevated train and streetcars, providing a little extra noise and activity above the ordinary commotion of early-20th-century life in New York City.

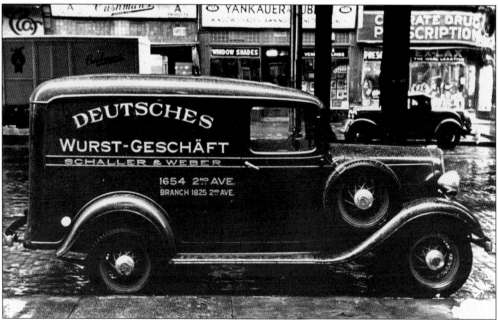

Here is a c. 1937 view of the west side of Second Avenue, between 85th and 86th Streets. A Schaller and Weber truck is parked on the street; the butcher shop had just recently been founded on the east side of the avenue when this photograph was taken. Note the German window shade establishment at 1655 Second Avenue.

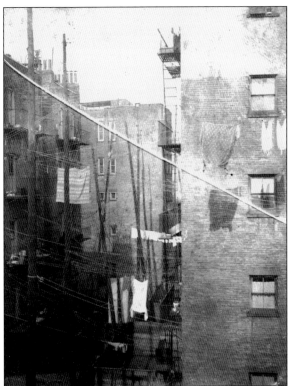

In the days long before automatic clothes dryers, the German residents of Yorkville typically strung their hand-washed laundry out on lines from their back windows and into the courtyards behind their tenement buildings, just as they had when they lived downtown. This photograph dates to around 1915.

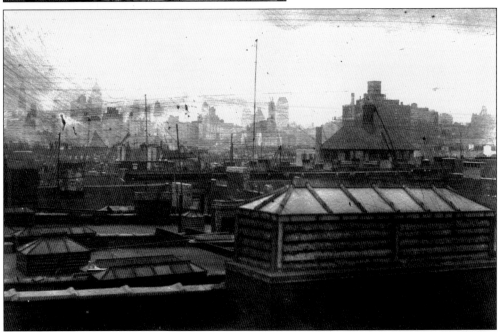

This photograph shows the view from the roof of a Yorkville apartment building around 1915 (probably looking south from 84th Street). Residents might occasionally go to their apartment buildings' roofs to get a breath of air, to look at the view of their city, or just to enjoy a few moments of privacy.

Although the apartments of Yorkville were technically considered to be tenements, they were a step up from the extremely crowded lodgings that many German immigrants had known downtown, in the neighborhood known as Kleindeutschland. This can be seen from the rather elaborate iron or stone stair railings and wooden doors of some of the Yorkville apartment buildings. Even if the insides of their apartments left something to be desired, the streetscape of Yorkville was pleasant. Shown here are photographs of Helen Schlag on the steps of her building on East 84th Street in about 1911 and Lizzie Thiele in front of a building on East 82nd Street during the 1940s.

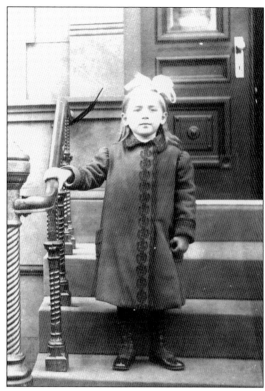

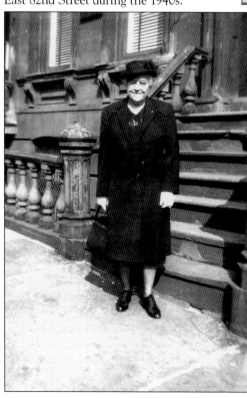

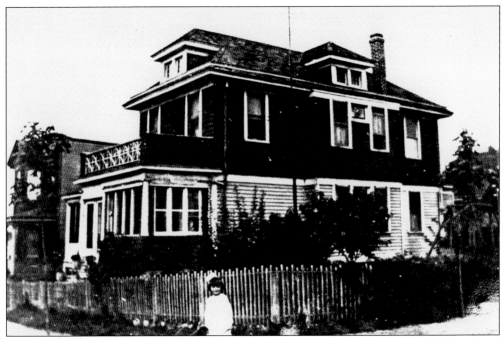

When the Muller family built this house in Elmhurst, Queens, just south of Queens Boulevard around 1915, it was one of only a couple of buildings on the block. Although ethnic Germans were concentrated in a few areas of the city, by the early 20th century, their presence was prominent in practically every neighborhood.

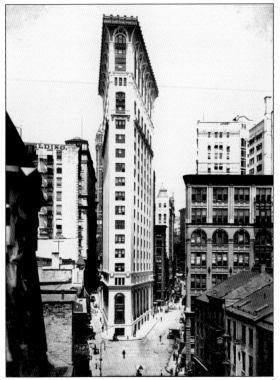

The German-American Building was built in 1907 at Liberty Street and Maiden Lane. The 20-story skyscraper was proclaimed as the newest of the "Flatirons" because it was similar in shape to the already-famous building at 23rd Street that had been constructed a few years earlier.

Stadt New York.

aus allen Theilen der

Herausgegeben vom New Yorker Herold. 22 & 24 North William Street, New York.

HENDRICK HUDSON — THE CLERMONT — ROBERT FULTON

The *New Yorker Herold* newspaper company published this booklet of New York City photographs in 1909. The 64-page booklet was probably aimed at the newly arrived immigrants, who could benefit from a guide to their new home, in their own language.

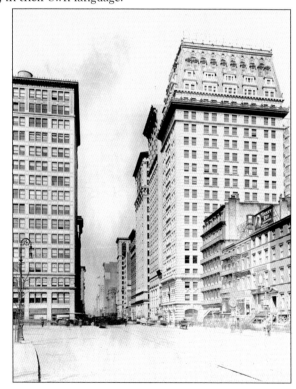

The Germania Life Building, located on Fourth Avenue (Park Avenue), was the headquarters of the Germania Life Insurance Company. Founded in 1860 by Hugo Wesendonck, the company's name changed to Guardian Life Insurance in 1917 (during World War I).

FROM THE
PHOTOGRAPHIC
STUDIO
OF

M. E. Muench

1472 THIRD AVENUE,

Bet. 83d & 84th Sts., New York.

The reverse of a photograph from about 1905 shows the advertisement of the photography studio that took the picture, M. E. Muench, located at 1472 Third Avenue in Yorkville. Before the 1920s, and the advent of the Kodak Brownie, few Germans had their own cameras. Photography studios were plentiful in German neighborhoods in the late 19th and early 20th centuries, and German American families frequented these establishments to have formal portraits taken. Many studios told customers that "copies can be had at any time." Many of the photographers were German, such as Shackell and Clauss (Third Avenue and 51st Street) and Klapper at 75th Street and First Avenue.

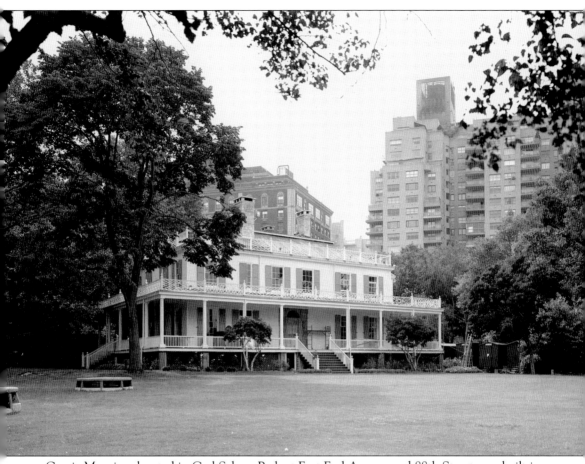

Gracie Mansion, located in Carl Schurz Park at East End Avenue and 88th Street, was built in 1799 by Archibald Gracie. It was eventually taken over by the City of New York and served as a concession stand. German American children played in the park; one Yorkville resident recalled playing jacks on the steps of Gracie Mansion. The house became the official residence of the mayor beginning in 1942.

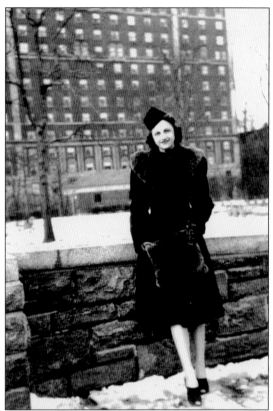

A newly married Eleanor Panchyk stands in Carl Schurz Park during the winter of 1943. At the time, she lived nearby on East 88th Street. Carl Schurz Park was a pleasant place for Yorkville Germans to take a walk on a summer day and enjoy views of the East River.

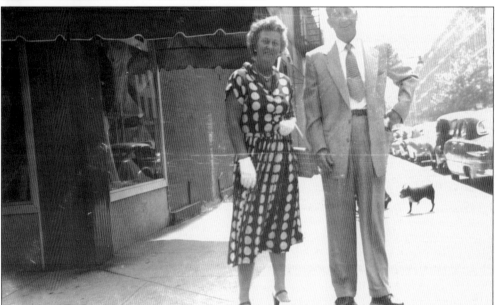

Ruth and Ernest Albrecht stand at the corner of York Avenue and 84th Street in July 1953. The German community of Yorkville was graying by this time, with many of the first generation German Americans in their 50s, 60s, and 70s. Their children, the grandchildren of the original immigrants, began to leave the neighborhood beginning with World War II.

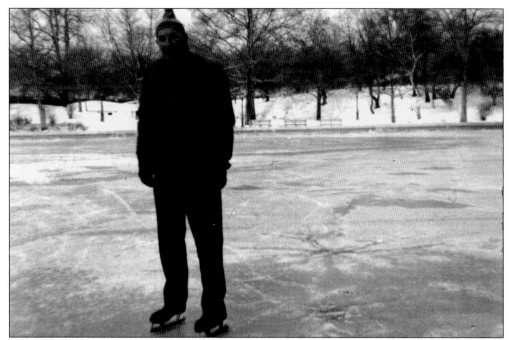

Retired policeman Ernest Albrecht skates on a pond in Central Park in 1968. One of the many advantages of living in Yorkville was its proximity to Central Park. German immigrants and their families could walk just a few blocks west and reach an urban oasis where plenty of free fun could be had. In winter, ice-skating was a popular pastime; many preferred to watch rather than skate. By the time this photograph was taken, the German flavor of Yorkville had begun to fade somewhat as the neighborhood changed and the children of German immigrants either died or moved away.

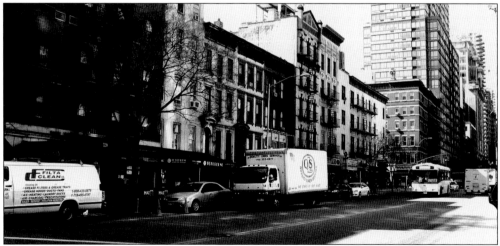

The very heart of Yorkville, 86th Street was perhaps the street most identified with Germans in the entire city of New York for many years during the early to mid-20th century. Today 86th Street is stripped of any signs of its German past. Although many of the buildings from the early 20th century still stand, new apartments and condominium towers have replaced some of the old buildings. This photograph offers a present-day view of 86th Street looking west toward Second Avenue.

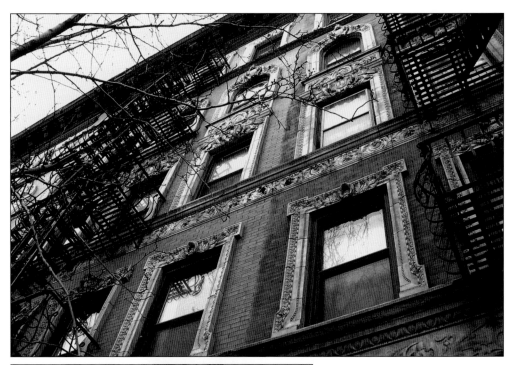

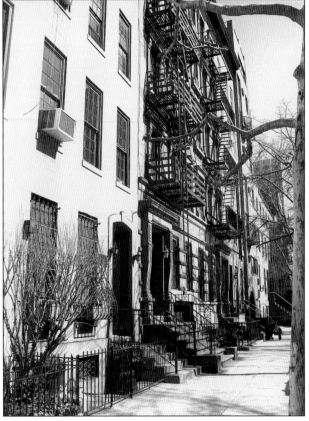

These two photographs give a sense of the flavor of Yorkville today. Some streets still look like they did in the late 19th century. One photograph shows architectural detailing on a century-old building at 312–314 East 84th Street. The other photograph shows an old fire escape on the front of a building, at 419 East 84th Street. While their exteriors offer a fascinating glimpse into the past, many of these charming old Yorkville residential buildings have become gentrified now, offering completely renovated, modern apartments to renters who are far wealthier than their original German tenants were. Although much of the original architecture of Yorkville is still intact, some old apartment buildings were knocked down to make way for condominium towers.

An unidentified woman walks down a Yorkville street during the 1920s. Note the plumbing and hardware store window behind her. Yorkville was a self-contained community, offering all amenities such that residents never had to leave its confines if they did not desire.

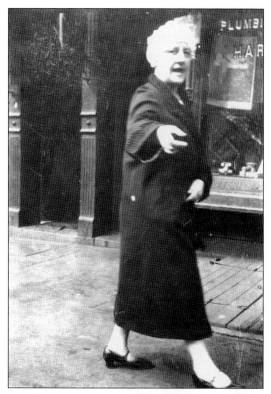

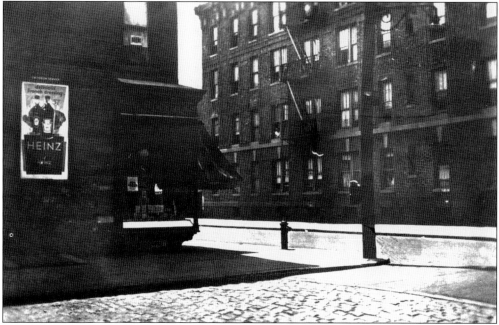

This is an image of a Ridgewood, Queens, street around 1930. During the 20th century, Ridgewood became one of the bastions for the German population in New York. In this photograph, note the sign for Heinz French dressing on the grocery store building. Heinz, founded in 1869 by Henry J. Heinz, was one of the most popular German brands.

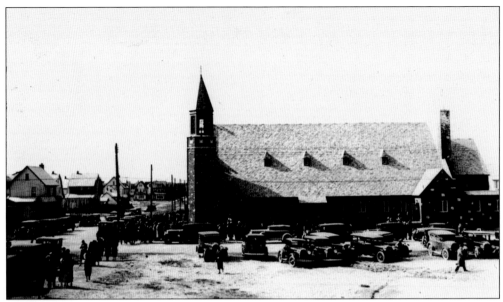

When immigrant Carl Prommersberger and family moved from Ridgewood, Queens, to Hollis, Queens (near Jamaica), in the early 1930s, they attended St. Pascal of Baylon Roman Catholic Church (shown here around 1932), located at 113th Avenue and 199th Street. They also lived for about eight years in the rooms on the second floor of a house, above the St. Pascal Parish Hall.

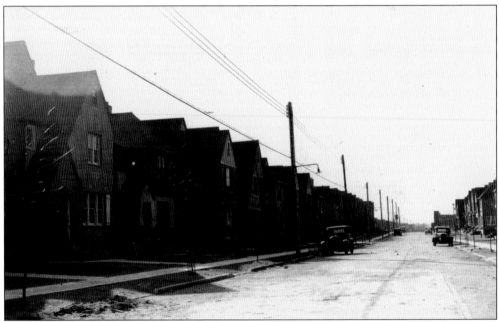

During the first half of the 20th century, many German Americans, often the children of immigrants, decided to move out of Manhattan and into the "suburbs," one of the outlying boroughs. When the Leyden family moved from Manhattan to Laurelton, Queens, in 1932, the neighborhood was still very new. Suburbs such as these must have seemed to be a million miles away from bustling Manhattan. Moves such as these benefited the German American population in the long run, but for some, like Mrs. Leyden, the adjustment was difficult to make.

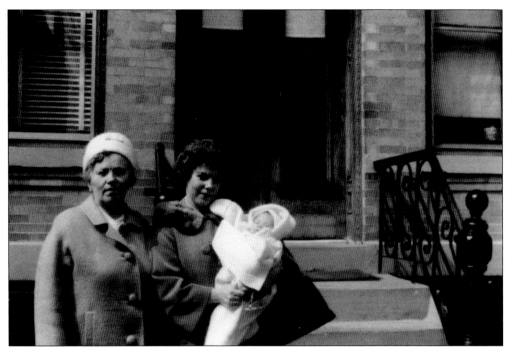

While Yorkville has struggled to retain its German heritage, three Queens neighborhoods have had more success preserving German culture. Ridgewood, Glendale, and Middle Village have been popular with German Americans for many years. Comfortable homes and pleasant surroundings offered the comforts and conveniences of a city, with many of the benefits of a suburb. In the photograph above, three generations of Unfrieds pose in front of a house on Madison Street in Ridgewood in 1966. In the photograph below, Anita Unfried poses in front of her family's house on Seventy-eighth Avenue in Glendale in 1972.

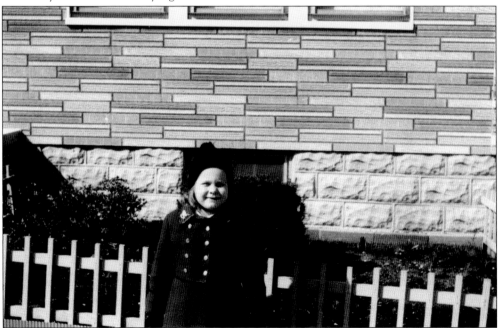

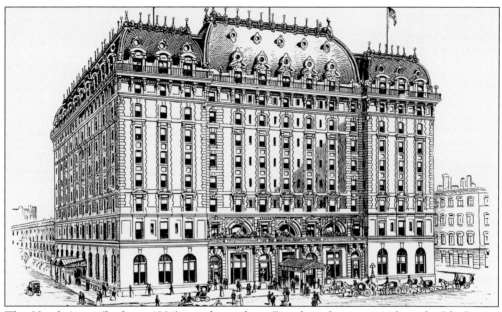

The Hotel Astor (built in 1904) was located on Broadway between 44th and 45th Streets and was the brainchild of William Waldorf Astor, a member of the famous Astor family. The founding father of the family was John Jacob Astor (born in 1763 near Heidelberg), who came to the United States in 1784, first to Baltimore and then New York City. He made a fortune in fur trading, and his family was prominent in New York City throughout the 19th and early 20th centuries. The hotel was demolished in the 1960s.

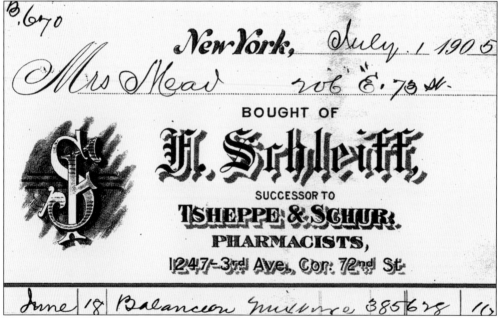

Frank Schleiff, born in 1867 in New York City of German parentage, lived at 119 East 72nd Street with his family and ran a drugstore at 1247 Third Avenue (at the corner of 72nd Street). He took over the drugstore operations from two Germans named Tscheppe and Schur. This is a receipt from 1905 made out to a Mrs. Mead of East 73rd Street.

This is a list of what one William Prager of 129 East 74th Street purchased at the Schleiff's Drug Store on 72nd Street between May and October 1905. Among other items, Prager bought various types of soap, insect exterminator, flypaper, witch hazel, camphor, corn remover, ointment, hair tonic, and boric acid. The purchases give some insight into the everyday lives of German Americans living in New York City; for example, insects and rodents were a big problem in crowded apartment buildings. Other German customers at the pharmacy included Zimmern, Lempke, Hammerschlag, Schoppert, Sturzelbach, Schopflocher, Bock, and von Schwanflugel. In those days, the drugstore had a more prominent role in American life. Many offered sandwiches and refreshments and served as a place where young people could socialize.

Many Germans in New York City were entrepreneurs of one kind or another. One Dr. J. H. Schenck took out a newspaper advertisement in 1866, touting his Mandrake Pills that could prevent cholera, a common and deadly disease during the 19th century, as well as liver disease.

This is an advertisement for the furniture maker J. F. C. Pickhardt (the initials probably stood for Johann Friedrich Christian) from an 1870 issue of *Appleton's Journal*. Pickhardt patented some of his furniture designs, including a cushioned foldout sofa bedstead in 1860 and 1866.

Stumpp & Walter Co.'s Florists' Plant Tubs

These Tubs have been made to compete in price with the very lowest priced Tubs on the market. The prices here offered are the very best that we can make, and the Tubs must be bought in the quantities as listed, in order to get the benefits of the quantity price.

Inside Measurements	PRICES			Inside Measurements	PRICES			Inside Measurements	PRICES			Inside Measurements	PRICES			Inside Measurements	PRICES		
	Height Width Each	Dozen	100		Height Width Each	Dozen	100		Height Width Each	Dozen	100		Height Width Each	Dozen	100		Height Width Each	Dozen	100
No. 1..6 in. 6	28c.	$2.80	$22.00	No. 4..9 in. 9	39c.	$4.40	$33.00	No. 7..11 in. 12	60c.	$6.60	$49.50	No. 10..14 in. 15	80c.	$9.25	$75.00	No.13..17 in. 18	$1.25	$16.60	$120.00
No. 2..7 in. 7	32c.	3.30	25.00	No. 5..10 in. 10	50c.	5.50	42.00	No. 8..12 in. 13	66c.	7.20	58.00	No. 11..15 in. 16	95c.	10.80	85.00	No.14..18 in. 19	1.45	16.80	135.00
No. 3..8 in. 8	33c.	3.85	27.50	No. 6..10 in. 11	55c.	6.00	47.50	No. 9..13 in. 14	70c.	8.00	66.00	No. 12..16 in. 16	$1.15	13.20	100.00				

IF any Grower would like a sample line of these Tubs, we will ship, freight paid, to any station East of the Mississippi River, a complete set of 14 Tubs for $10.00. If the Tubs are not satisfactory they can be returned and your money will be refunded.

Stumpp & Walter Co.

Specialty Department
50 Barclay Street
NEW YORK

Stumpp and Walter Company was a nursery and supply company founded by George G. Stumpp in 1897 at 50 Barclay Street.

New Yorkers of German descent could always rely upon their local German-language newspapers to provide them with advertisements from German businesses. For those who had immigrated to New York City, German establishments helped them feel more at home in the big city, even after many years had passed since their arrival.

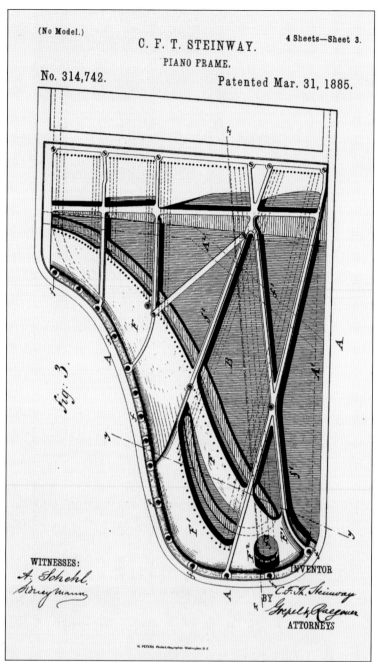

Steinway and Sons was founded in Manhattan in 1853 by Henry E. Steinway (the name was originally Steinweg), an immigrant from Germany. The firm quickly grew to become one of the most respected and renowned piano manufacturers in the world. Operations moved to Astoria, Queens, in 1870 (which was named after the Astor family and had a considerable German population). Steinway Street in Queens is named after the prominent family. Shown here is a patent for improvements to piano frames, submitted by C. F. T. Steinway in 1885. Technological innovations in piano design and manufacture and a reputation for excellent sound quality helped keep Steinway at the forefront of the industry.

Harry Becker owned and operated the Bayside Photo Studio, on Bell Boulevard in Bayside. Like many other ethnic groups in New York City, German Americans often trusted and patronized establishments run by their fellow countrymen, even if it meant going a little out of their way to get there. In this 1937 photograph, a German family from Hollis calls on their friend Becker at his studio.

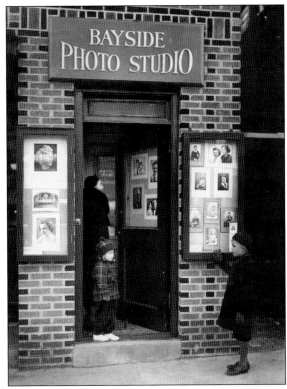

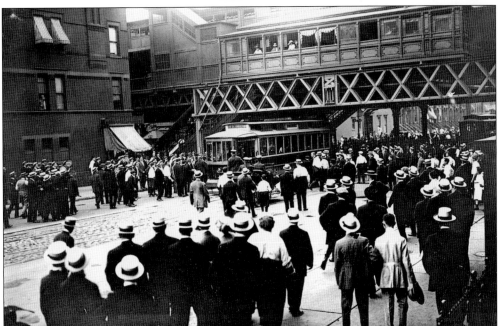

Transportation in early-20th-century New York City was excellent. For those Germans who lived in Yorkville, travel downtown or across town was a trolley ride or a subway ride away, except when there was a strike, as shown in this photograph from 1916, depicting a stopped trolley car at the intersection of 86th Street and Sixth Avenue.

Eimer and Amend was begun in 1851 by Bernard Amend, who emigrated from Germany to America in 1847. He was soon joined by partner Carl Eimer. Located at the corner of 18th Street and Third Avenue, the pharmaceutical company provided drugs and chemical laboratory supplies. In 1940, a company called Fisher Scientific bought Eimer and Amend. The image at left is an advertisement for Dr. Seibert's milk-sterilizing apparatus, a product sold by Eimer and Amend in 1903. Pictured below is an Eimer and Amend dinner function, around the 1940s.

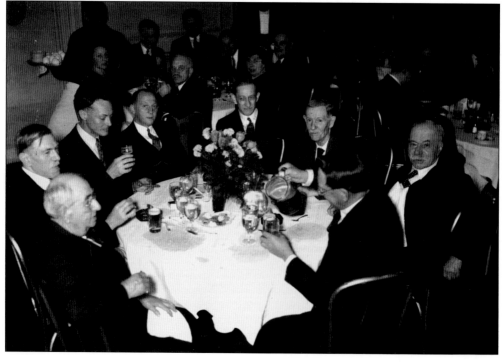

Three

PEOPLE

Celebrating German New York City is really celebrating its people. So many German New Yorkers played a role in the culture and development of the city, it would require several books to detail each of them. Rather this chapter presents a sampling of some German New Yorkers, both famous ones and ordinary, everyday folks. Every German American was important in his or her own way. Although most German New Yorkers had many common denominators growing up, each had their own unique experience. Each German American story helps create a crazy quilt picture of what life was like for German immigrants and their descendants living in New York City.

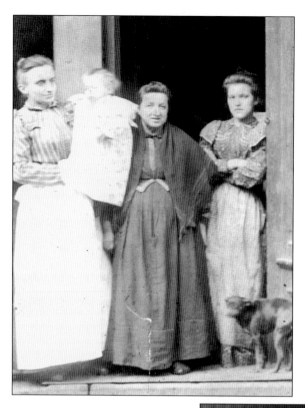

When Maria Elisabetha Mohr (born in 1848) arrived in New York City in the early 1870s, she lived on 76th Street in Yorkville. Married in 1873, she had 11 children. Only four of them survived childhood. Disease was a problem for families living in crowded tenements. She is shown here (at center) in the doorway of her apartment on 78th Street about 1901.

Edwin Leyden, born in 1848 in East Prussia, came to the United States in 1881 at the age of 33. He was a chemist and lived on Chatterton Avenue in the Bronx in 1910. His wife, Johanna, was born in Oldenburg. They moved to New Jersey, but after his wife died, he moved back to the Bronx and lived with his daughter and son-in-law on Seward Avenue. Those immigrants who came to New York City as adults were more likely to have a heavier German accent and hold on to more of their German traditions and customs than were those who arrived as children and went through New York public schools.

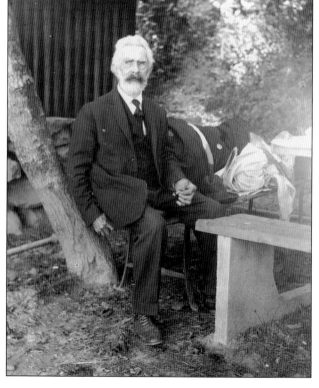

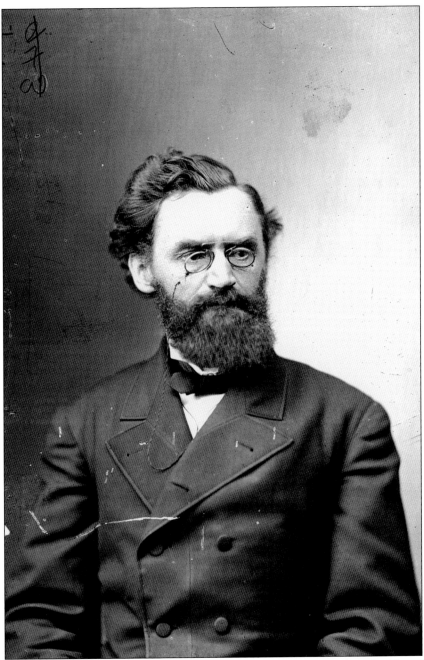

Carl Schurz was born in Liblar (near Cologne) in 1829 and immigrated to the United States in 1852. He first lived in Pennsylvania, Wisconsin, and Missouri. He ran unsuccessfully for governor of Wisconsin, served as a Union general during the Civil War, and was subsequently elected as a senator from Missouri (1869–1875). He was picked by Pres. Rutherford Hayes to be the secretary of the interior (1877–1881) and then moved to New York City, where he was editor of the *New York Evening Post* and was active in local politics. He was also a contributor to *Harper's Weekly*. He died in New York in 1906. Carl Schurz Park in Yorkville was named in his honor in 1910.

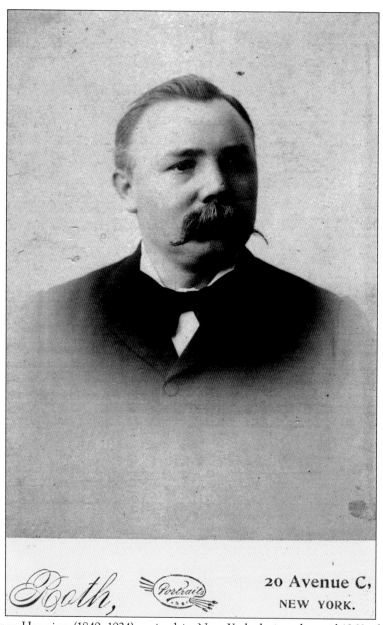

Roth, Portraits

20 Avenue C,
NEW YORK.

Walter Henry Henning (1849–1924) arrived in New York during the mid-1860s from Geisa, Sachsen-Weimar-Eisenach. Originally a butcher by trade, he became active in German American politics. After the German-born Edward Tamsen was elected sheriff of New York in November 1894, Henning was one of the deputies that Tamsen selected, at a salary of $2,500 per year. Henning had run for assemblyman that year on the New York State and Empire State Democracy Party ticket but lost. During his political career, Henning attended many events held by the German-American Reform Union, a powerful late-19th-century city political organization that tried to influence city politics. At one event, the speakers included the illustrious Carl Schurz. Deputy Sheriff Henning eventually resigned in 1897 over a disagreement with Sheriff Tamsen. He later became chief clerk of the Bronx County Coroner's Office and also worked in real estate.

Henning's obituary appeared in the *Staats-Zeitung* newspaper in August 1924. The German-language newspapers of New York City covered news and births, marriages, and deaths that were not mentioned in the English-language newspapers. The obituary said that with the death of Henning, the Germans of the Bronx had "suffered a sharp loss."

Tote des Tages.

Walter H. Henning.

Mit Walter H. Henning, der am Montag vom Tode ereilt wurde, hat das Deutschtum des Bronx einen herben Verlust erlitten. Herr Henning nahm vor Jahren an der politischen Reformbewegung einen lebhaften Anteil und war lange Zeit Distriktsführer im Deutsch-amerikanischen Reformbunde. Von 1902 an bekleidet* er mehrere Jahre das Amt des Chefclerks im Coroners Bureau, Bronx. Herr. Henning wohnte in 829 Crotona Ave., Bronx. Die Beerdigung ist privat.

Leonard Ruoff.

Aus Bremen ist die Nachricht eingetroffen, daß dort der Leichenbestatter

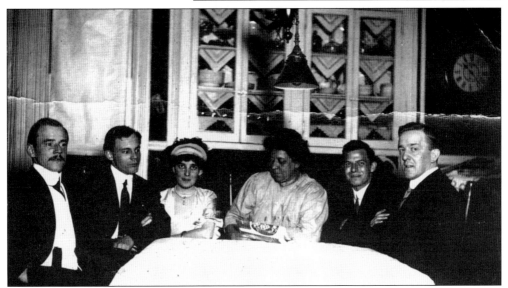

From left to right, Arthur Henning and Milton Henning sit with Milton's fiancée Elsie Weyhausen, their mother, Elizabeth Henning, and two family friends in about 1910, in the process of planning Milton and Elsie's wedding. The photograph was taken at the Henning family home at 1829 Crotona Avenue in the Bronx. By the first decade of the 20th century (and following its incorporation into New York City), improved transportation made the Bronx a more attractive locale for some German residents of Manhattan, though there had already been a German community in the Morrisania section of the Bronx during the 19th century.

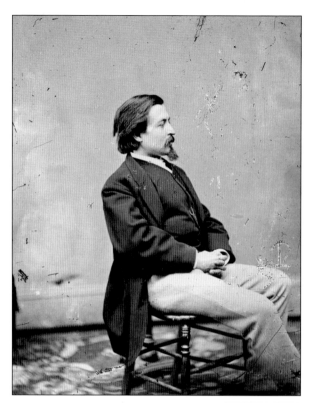

Illustrator Thomas Nast was born in Landau, Bavaria, in 1840 and came to New York City in 1846 with his family. As a young man, he took classes at the Academy of Design and soon got a job drawing cartoons for *Leslie's Weekly*, followed next by *Harper's Weekly*. Nast was famous for two things: first, for his drawings that brought the scandals of the corrupt New York City mayor "Boss" Tweed to light, and second, for his revolutionary drawings of Santa Claus. With his first illustration of Santa Claus in 1863, Nast was responsible for creating the "modern" image of Santa Claus, as he is known today. Shown here are a photograph of Nast and an 1892 Nast drawing of Santa Claus being hugged by a child.

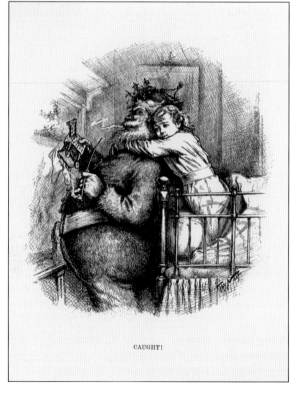

CAUGHT!

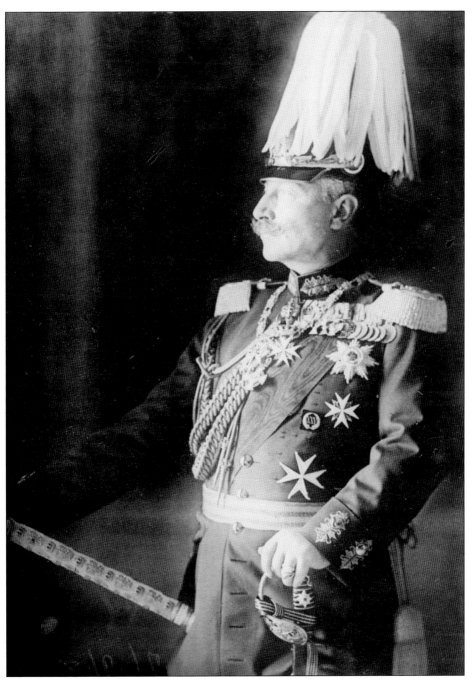

Over one million Germans immigrated to the United States during the reign of German kaiser Wilhelm II (1859–1941). Although many of them had no regrets about leaving Germany for America, they still thought fondly of the most powerful man in their fatherland, who reigned as king of Prussia and kaiser (emperor) of Germany from 1888 to 1918. Wilhelm II was preceded in power by his grandfather Wilhelm I (1797–1888), who reigned from 1871 to 1888. Those German Americans who became naturalized citizens of the United States had to sign an oath declaring they renounced their allegiance to the emperor.

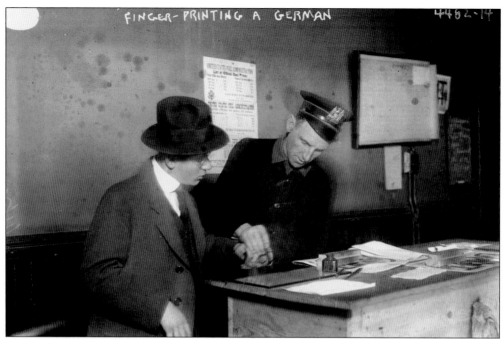

After the United States entered World War I (known at the time as the Great War) in 1917, animosity and suspicions of German Americans increased. Depicted here is a New York City policeman fingerprinting a German man in 1917. Once the war ended in 1918, it was back to normal, and once again being German in New York City did not carry any stigma—at least until World War II broke out.

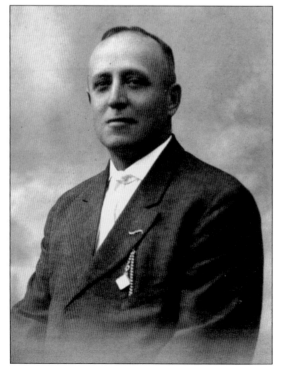

Albert Thiele was born in Berlin in 1874. He immigrated to New York City with his family in 1879 and settled at first in Brooklyn and then in Yorkville. His father, Robert Thiele, was a bookbinder in Berlin. Albert became a painter and was friendly with another German immigrant, Robert F. Wagner, future United States senator.

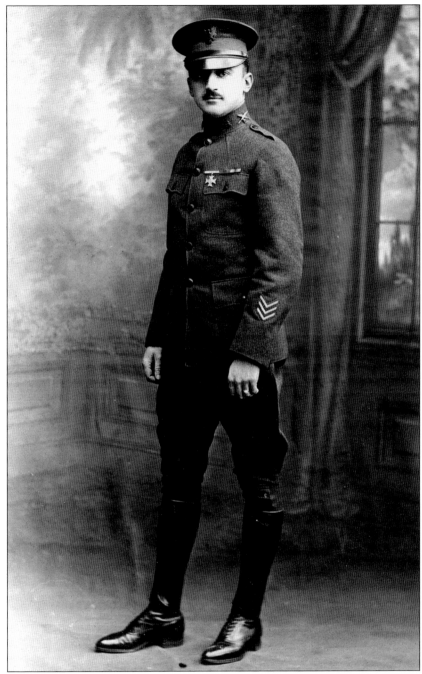

The German American man from Yorkville shown in this photograph was drafted into the army during World War I. He was about 22 years old when the photograph was taken in 1918. Many German Americans in New York City were either drafted or enlisted in the Great War. For these soldiers, there was no question as to their loyalties; they were Americans willing to fight for their country, even if it meant opposing the land of their forefathers. The same applied during World War II, when many German Americans in New York City enlisted in the fight against the Nazis.

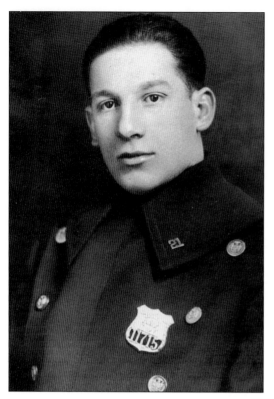

German Americans in New York City often served their city in the line of duty. The son of German immigrants, Ernest Emil Albrecht (born in 1900) became a New York City policeman during the early 1920s. His brother Gustave also was a policeman, while his brother-in-law William was a fireman. For some years, Ernest was stationed at the East 104th Street precinct. In 1925, he was shot in the hand by robbers speeding away from a crime scene at 98th Street and Second Avenue in a getaway car.

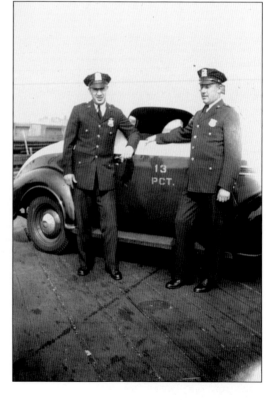

Ernest Albrecht (left) was a childhood acquaintance of the actor James Cagney (who, though Irish, was also raised in Yorkville), and whenever Cagney came back to Yorkville to visit, he would say hello to patrolman Albrecht as he walked the beat. Albrecht is pictured here with his partner on the lookout for holiday high jinks on July 4, 1939.

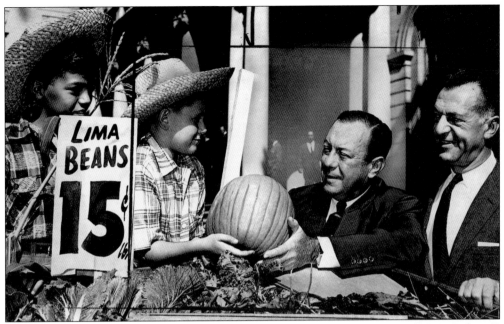

The Wagners were a famous German father-and-son political force in New York City. Robert F. Wagner (1877–1953) was born in Hesse-Nassau and arrived in New York City in 1885. He attended City College and graduated in 1898. He was elected senator in 1926 and served four terms (1927–1945). He played a major role in implementing the Social Security Act and the Wagner Labor Act in 1935. His son Robert F. Wagner Jr. (1910–1991) served three terms as mayor of New York City (1954–1965) and helped oversee the city's hosting of the world's fair in 1964–1965. This photograph shows Mayor Wagner buying a pumpkin in the Bronx in 1958.

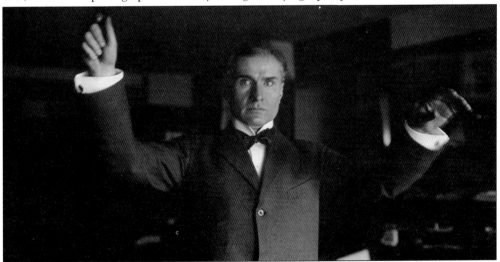

Walter J. Damrosch (1862–1950) was a conductor who was born in Breslau, Prussia, and came to the United States with his family in 1871. His father, Leopold (1832–1885), was also a composer and conductor. The younger Damrosch served as assistant conductor at the Metropolitan Opera in 1884–1885 and founded the Damrosch Opera Company in 1894, among many other accomplishments. He was married to Margaret Blaine, daughter of former presidential candidate James G. Blaine. Public School 186 in the Bronx was named in his honor.

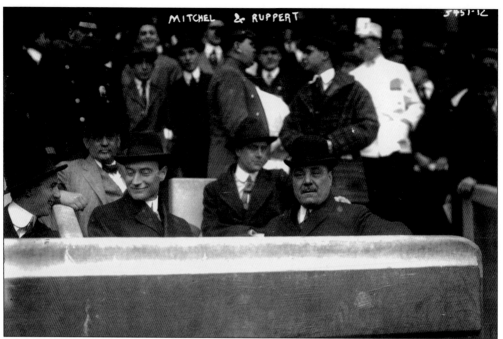

Jacob Ruppert (1867–1939, seated front right) was born in New York City, the son of a German American beer-brewing magnate. He served as a congressman before purchasing the New York Yankees baseball team in 1915 and remained the team's owner until his death. During the 1920s, his team had one of the greatest lineups in baseball history, featuring, among others, a German American first baseman named Lou Gehrig.

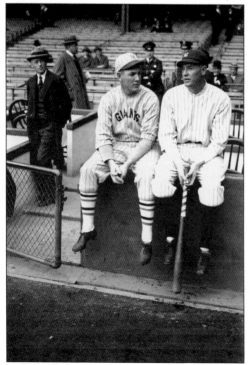

Emil F. Meusel (1893–1963) of the New York Giants poses with his brother Robert W. Meusel (1896–1977) of the New York Yankees in October 1923. Although born of German parents, Emil was nicknamed "Irish." He played for the Giants between 1921 and 1926, while his brother Robert played for the Yankees from 1920 to 1929. They faced each other in several World Series during the 1920s.

A seven-year-old newsboy named Johann Lehman poses in front of a building in 1907. It was common for children under the age of 10 to work and provide a little additional income to their families. During the 20th century, child labor laws put an end to the practice.

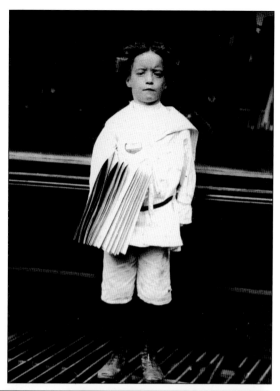

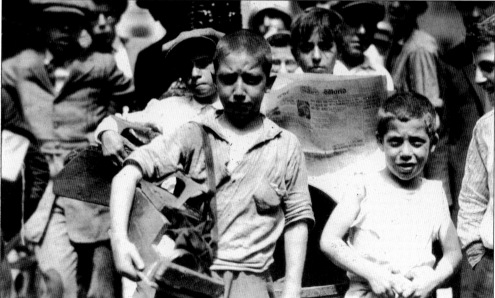

Children of German immigrants often had to work at very young ages to help support their families. For those who did not help out in the family business, there were many other options, such as selling newspapers or serving as a bootblack, like the children shown in this early-20th-century image. Lizzie Thiele, of 78th Street, told her daughter about the hardships of her youth and how she was sent alone at the age of seven, from Yorkville, miles downtown to pick up corks for the family business.

Conduct of AARON BURR, towards poor German family.

This image is an 1804 broadside poster berating Aaron Burr (at the time a candidate for governor of New York) for his conduct "towards [a] poor German family." It seems that Albrecht Behrens, a native of Bremen, died before his will could be completed, and Burr stepped in and became the administrator of the estate, skimming a small fortune from the estate and leaving the orphaned children without the money that was due to them.

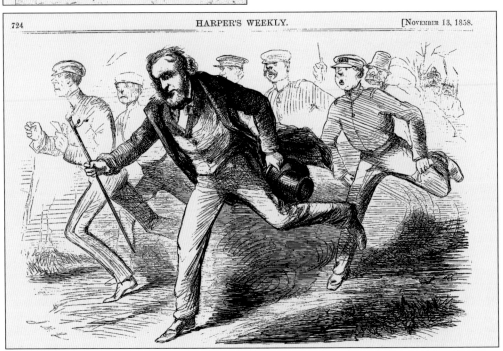

Mayor Daniel F. Tiemann (1805–1899) is depicted in a political cartoon in 1858. Tiemann served one term, from 1858 to 1860, and was one of only a few New York mayors who were of German descent. Outside of his political life, he was a successful paint dealer.

Louise Bach and her brother Charles look quite dapper in this 1904 studio photograph. Only families that were above the poverty level could afford such a luxury; few families owned their own cameras in the early 20th century. Candid snapshots of average German American families were not common until the 1920s or later.

Louise Bach and her two children, Louise and Charles, mourned the loss of husband and father William Bach in 1912. A plumber, he had been badly injured in an underground fire in 1905, and he eventually died of his injuries. His widow remarried in 1913. Her new husband was friendly with German-born Robert F. Wagner (the United States senator and father of the future mayor) and through this connection daughter Louise was able to get a job at Metropolitan Life in Manhattan after she graduated high school.

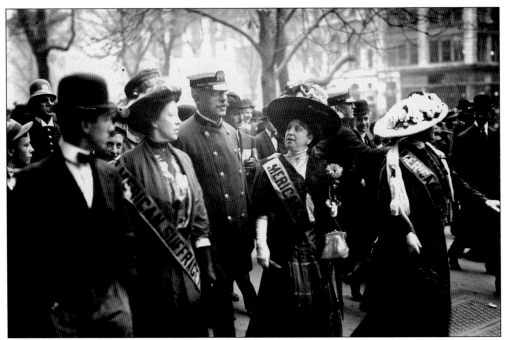

Some German immigrants changed or shortened their last names after arrival in New York City, so as not to be so conspicuously ethnic. For example, Schmidt could become Smith, Braun could become Brown, and Langbein could become Lang. Capt. Max Schmittberger, of the New York City police force, was one who did not change his name. He is shown here serving as an escort to suffragettes near city hall in 1908.

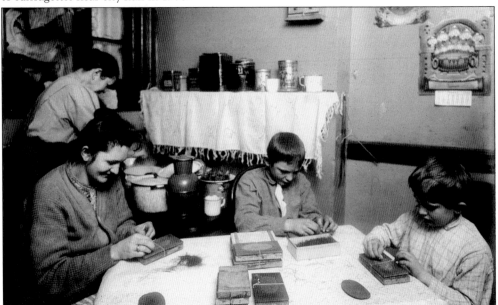

Immigrant families sometimes also used their home as their place of business. This photograph, taken in January 1912, shows the Hausner family of 310 East 71st Street making hairbrushes. Six-year-old Frank and 12-year-old John worked with their mother until 10:00 p.m. Their father was a motorman, but this was a way to make some extra money, about $2 per week.

68

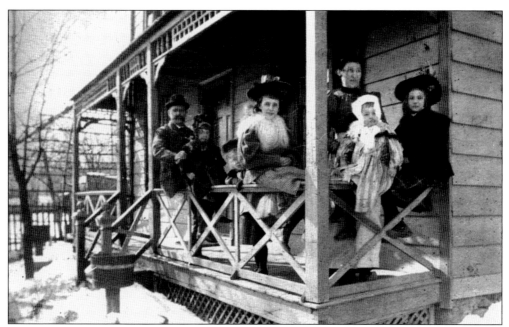

This photograph of the Weyhausen family and friends on their front porch in the Bronx was taken around 1897. The Weyhausens arrived in New York City in May 1888 aboard the *Eider* sailing from Bremen. Father Heinrich Weyhausen, a beer brewer, is at far left, mother Marie Weyhausen is holding baby Frieda. The two girls in hats are Elsie (left in white fur collar) and Anna Wilhelmina Weyhausen (right).

By the late 19th century, there was a steady stream of newly arrived German immigrants, but there were also more established families that had managed to climb the social ladder. Several German names appear on this page from the 1893 *New York City Social Register*. The introduction to the books says it "records the names and addresses of the several members, grouped together, of Prominent families with their club memberships."

NEW YORK. 261

Schaff Mr&Mrs Philip-C........................15 E 43
Schefer Mr&Mrs Carl-Dv. Rh. Mc. Rf........40 W 37
Schefer Mr&Mrs Ernest F (Constance Bonner)
 Rh..West Brighton S I
Schell Mrs Augustus (Anna M Fox)..........17 W 33
Schell Mr Edward-M. C. Dt. Ay.......
Schell Miss..............
 53 Clinton Pl
Schell Mr&Mrs Edward Heartt (Cornelia E Barnes)
 M. Sn. Y'70..19 E 24
Schell Mr&Mrs Francis (Mary Stewart Morris) Y'72
 21 E 62
Schell Mr&Mrs Robert-Sn.....................33 W 56
Schenck Mr&Mrs C Stewart (Hattie Kearny) | Riverdale
Schenck The Misses........................ | on
Schenck Mr Stewart Courtney....... | Hudson
Schenck Mr H de B-Cal....................Calumet Club
Schenck Miss Ida J..........................
Schenck Miss Anna P........................ | 30
Schenck The Messrs Spotswood D & Dorsey N H | W 34
Schenck Mr&Mrs J Fred'k (Stone) Un.Rh. | 74 Willow
Schenck Miss Aleid.............[Mt. Ny. | Brooklyn
Schenck Mr&Mrs N Pendleton (Morgan)
Schenck Mr Remsen-Sn.............St Nicholas Club
Schermerhorn Mr&Mrs Chas Aug | 270 Boulevard
 (Louise Schermerhorn) Sv. Ins. Rv. | cor W 73
Schermerhorn Miss Rosalie............
Schermerhorn Mr Fred'k Augustus
 Un.Mr.K.T.C.Rh.Cy.S.Ny.Rg.Cl'68..61 University Pl
Schermerhorn Mr&MrsGeorge Stevens(Gibert)Sv. |
Schermerhorn Miss........................ | 6
Schermerhorn Mr Arthur F-Sv. Us............ | Wall
Schermerhorn Mr Edward Gibert-Sv.. |
Schermerhorn Mr&Mrs J Egmont(Cotting)
 K.Uv.Cal.Mt.Lc.Ny.S.Dt.Cy.Fn.'72. ..25 E 79
Schermerhorn Mr&Mrs J Maus (Brown)Uv.L.'69..48 E 26
Schermerhorn Mr Wm B-Un. Cl'63........Union Club
Schermerhorn Mr&Mrs Wm C (Cottenet)
 K. C. Mt. W. Cl'40..49 W 23

To A. F. Weeks

PLEASE TAKE NOTICE.

→◦←

At a sale of lands for unpaid taxes, for the year 1877, in the Town of Flushing, Queens County, State o New York, made by the Treasurer of said county, after due notice and adver-tisement, as provided by law, which sale was made at the Town Hall, in the village of Flush-ing, in said county, the 10th day of July, 1879.

G. Edward Carll

The town of Flushing purchased for a term of 1000 years, pursuant to the provisions of Chap. 268 of the Laws of 1877, and Chap. 226 of the Laws of 1878, certain lands assessed to

A. F. Weeks of which you appear to be the *Owner*, viz: *District 2. Block 43. Old Lot No 10. New Assessment No. 576.*

for the sum of $ *3 63* , and by the Laws of the State of New York, you are allowed fifteen (15) months from the said 10th day of July, 1879, to redeem said lands, by the payment af the above sum of $ *3 63* , with interest at the rate of twelve (12) per cent. per annum, from and after the above 10th day of July, 1879, together with one dollar additional fee for the service of this notice, all of which can be paid to the County Treasurer at his office in said county.

G. Edward Carll

If not redeemed before the 10th day of October, 1880, the said town will be entitled to a lease of said premises.

G. Edward Carll

Dated *July 6th* 1880.

G. Edward Carll was a prominent citizen of Flushing. Born in Manhattan, he moved to Flushing during the 1860s and was elected the treasurer of Queens County in 1876. He also served as village treasurer and village tax collector of Flushing. He died in 1898 at the age of 70. Shown here is a certificate of sale from a property in Flushing for taxes owed.

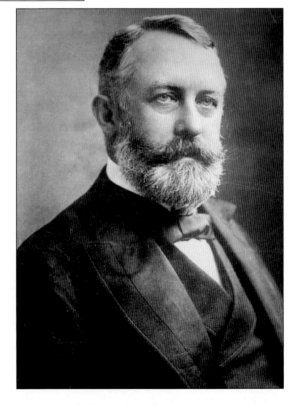

Originally from Pennsylvania, Henry Frick was born of German parentage. He became rich at a young age thanks to investments in the coal business. Frick moved to New York City in about 1900. He lived in an elegant mansion on Fifth Avenue and 70th Street until his death in 1919. The building is now a museum that showcases his extensive art collection.

Former deputy sheriff of New York County Walter Henry Henning relaxes on his porch at his summer home in Walden, New York. Henning's family's movements over time were representative of many German New Yorkers. Like Henning, many German New Yorkers started out in Kleindeutschland and later moved uptown or to one of the other boroughs. One of Henning's four children stayed in the Bronx, two moved to Dutchess County, and one to Long Island.

Dr. Henry Kissinger (at right, walking with Pres. Gerald Ford in 1974) is one of the most famous German American New Yorkers in recent history. He arrived in New York City in 1938 from Bavaria and went on to become the secretary of state in the 1970s, and then to run a consulting business in New York City.

German New Yorkers took pride in Pres. Dwight Eisenhower (1953–1961), one of a select few presidents with German heritage. Eisenhower (whose family's name in the 1700s was originally Eisenhauer) is seen seated in the first row in this photograph, campaigning for Richard Nixon (at the podium) on Long Island in the fall of 1960.

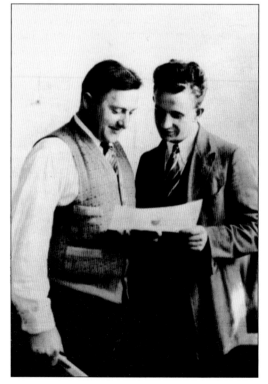

This 1930s photograph shows George Ernst Hantscho (left), the founder and owner of the George Hantscho Company, which manufactured printing presses. Carl Prommersberger (right) worked for the Bommer Spring Hinge Company in Brooklyn, founded in 1876 by Lorenz Bommer (and now called Bommer Industries).

Four

RELIGION AND EDUCATION

As German immigration increased during the mid-19th century, so to did the number of Lutheran and Catholic churches catering to those populations. From Kleindeutschland to Yorkville to Bushwick to Middle Village, religion was an important part of the German experience in New York City. Likewise education was a critical component of German life. In fact, it was the wife of the German politician Carl Schurz who had been responsible for introducing the concept of kindergarten in the United States; the first kindergarten opened in Wisconsin in the 1850s.

In neighborhoods such as Yorkville, the local schools were heavily German, but as the German population spread throughout the boroughs, there were plenty of German Americans represented in every classroom around the entire city. For those who wished to give their children a more German experience, both churches and private German schools offered that opportunity.

The Reformed German Church of New York existed before the Revolutionary War, attesting to the early immigration of Germans to New York City. George Washington wrote several letters to the minister and members of the church, thanking them for their kindness. Shown is a lottery advertisement to raise money to pay off the church's debts in 1772.

The German Hospital was located at 77th Street and Park Avenue (then known as Fourth Avenue). In 1869, the hospital received a major $50,000 gift from a wealthy German named Baron von Diergardt. This engraving depicts a flower show that was held at Fifth Avenue and 28th Street in March 1885 to benefit the German Hospital. In 1918, the name was changed to Lenox Hill Hospital.

The Lutheran Immanuels Church (seen here around 1900), located at 213–215 East 83rd Street, was one of several churches in Yorkville that catered to the largely German population. In 1917, it became the Church of St. Elizabeth of Hungary; there was a significant Hungarian population in Yorkville.

Immanuels-Kirche

Deutsche
Sprach- und Religionsschule
der Evangelisch Lutherischen
Immanuels-Gemeinde.

213-215 Oft 83. Strafe, zwifchen 2. und 3. Avenue.

Es wird hiermit zur Anzeige gebracht, daß die Evangelisch-Luth. Immanuels-Gemeinde, Oft 83. Strafe, zwifchen der zweiten und dritten Avenue, ihre bisherige Nachmittags- und Samstagsschule für deutsche Sprache und Religions-Unterricht auch im nächsten Jahre fortführen wird. Seit nun vier Jahren hat sich diese Schule als vortreffliches Institut bewährt. Die Kinder haben deutsch lesen, schreiben und reden gelernt, und, was noch unendlich mehr ist, sie sind in der biblischen Geschichte und im Katechismus, also in Gottes Wort, unterrichtet worden. Das ist ein Segen fürs ganze Leben, ja, für Zeit und Ewigkeit. Um dieses großen Segens willen haben wir uns entschlossen, keine Opfer zu scheuen.

Den Kindern, welche die Public Schools besuchen, ist hiermit eine unübertroffene Gelegenheit geboten, nicht nur die deutsche Sprache gründlich zu erlernen, welches für sie später geschäftlich von großem Nutzen ist, sondern sie werden auch in Gottes Wort unterrichtet, damit sie nicht religionslos aufwachsen.

Das Schuljahr ist auf 11 Monate festgesetzt und in 4 Quartale eingetheilt, das Quartal zu circa 11¼ Wochen berechnet. Ein jedes Kind muß sich mindestens auf ein Quartal verpflichten und dafür in Vorausbezahlung ein Schulgeld von $1.50 entrichten. Wir hoffen, indem wir das Schulgeld so unverhältnißmäßig billig gestellt haben, daß alle deutschen Eltern ihren Kindern den Nutzen und Segen unserer Schule zutheil werden lassen und uns in unserem wichtigen Unternehmen allseitig unterstützen. Unsere Schule ist jetzt in zwei gesonderte Klassen eingetheilt, die von einem competenten Lehrer unterrichtet werden. Eine jede Klasse erhält an drei Tagen in der Woche Unterricht, und zwar wie folgt:

I. Klasse: Montags, Mittwoch und Freitags von 4—½6 Uhr Nachmittags;

II. Klasse: Dienstags und Donnerstags von 4—½6 Uhr Nachmittags u.b Samstags von 9—12 Uhr Vormittags.

Schüler können jederzeit eintreten.

C. J. Renz, Pastor. Kurt E. Richter, Lehrer.
213 Oft 83. Str. 1252 Lexington Ave.

This is a flyer for the Evangelical German Language and Religion School at the Immanuels Church on East 83rd Street, around 1900. These children, often kids who were born in New York to German immigrant parents, learned how to speak, read, and write in German. The school year for this special school was 11 months long, broken into four quarters. The teacher's name was Kurt Richter.

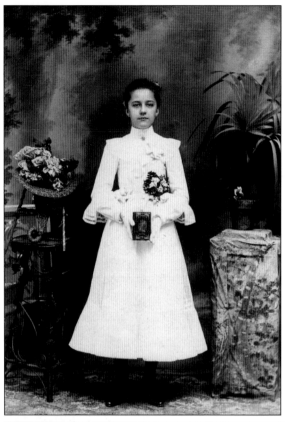

The image below is the program from a confirmation ceremony on Palm Sunday, March 23, 1902, at the Lutheran Immanuels Church located on East 83rd Street. The confirmation examination was held on March 16, 1902. The group included 19 boys and 20 girls. In the photograph at left, a white-gloved Minna Voigt is seen posing in a photograph studio with the *Lutherisches Gesangbuch* that she received for that special occasion. Also inside the book were the Augsburg Confession, epistles, and numerous prayers. Each of the children who made confession that day likely received this book, with their name in gold lettering on the front.

Namen der Confirmanden.

— ❧ —

Knaben.	Mädchen.
Als, Philip	Anderson, Meta Pauline Friedericke
Arfmann, Christian Johann	Beisner, Meta
Brunckhorst, Henry	Bluemer, Lillie Minna Florence
Diller, August Friedrich	Guenckel, Anna
Emmler, Christian	Ickowsky, Fanny
Freese, John	Meyer, Emma
Fraas, Charles	Messenkopf, Lina
Froehlich, Herman Erdman Gotthilf	Nadermann, Anna Margarethe Elisabeth
Gerdes, Friedrich Georg	Oelkers, Annie Rabecca
Hauser, Andreas Matthias	Oest, Auguste Mathilde
Hoops, John Wilhelm	Pilz, Elisabeth Hermine
Hamann, Karl Johannes	Queitzsch, Anna Rosa
Kruger, Henry	Regling, Emma Louisa Maria
Kruse, Frederick Augustus	Sallmann, Martha Minna
Landwehr, Henry John Diedrich	Schilling, Lina
Mehrtens, John Diedrich	Vagts, Louise Catharina
Messenkopf, John Philip	Volk, Elisabeth
Semmen, Louis Henry	Voigt, Minna Lina Julia
Woessner, Alfred	Voss, Hattie Pauline
	Weisenberger, Katie

— ✳ —

Prüfung der Confirmanden:

Sonntag, den 16. März, Vormittags 10.30

Confirmation:

Palm-Sonntag, den 23ten März, Vormittags 10.30.

Abendmahl:

Grün-Donnerstag, den 27ten März, Abends 7.30,

Char-Freitag, den 28ten März, Vormittags 10.30 ; Abends 7.30.

Beichtgottesdienst um 10 Uhr und um 7 Uhr.

Oster-Sonntag, den 30ten März, Vormittags 10.30 ; Abends 7.30.

Beichtgottesdienst um 10 Uhr und um 7 Uhr.

Anmeldungen vorher, entweder persönlich oder durch Karten.

Zu den bevorstehenden Gottesdiensten ergeht hiermit eine herzliche Einladung an Alle.

C. J. RENZ,

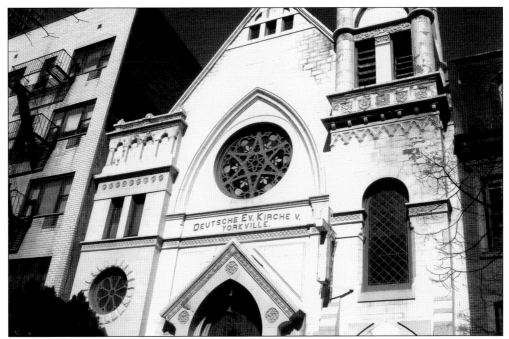

The handsome Zion St. Mark's Church (Lutheran) at 339 East 84th Street in Yorkville is one of the last remaining symbols of a once glorious German past in the neighborhood. The Zion congregation was founded in 1892 in Yorkville; the St. Mark's Church was founded in 1846 on the Lower East Side. The two were combined in 1946 after the German population had almost completely shifted from downtown to Yorkville.

The St. Joseph's parish (Catholic) was founded in 1873 and catered to mainly German parishioners. The first church was built in 1874, and a larger church was built in 1894. The building still stands at 404 East 87th Street, though there are few German parishioners left. In April 2008, Pope Benedict XVI held a prayer service at St. Joseph's Church.

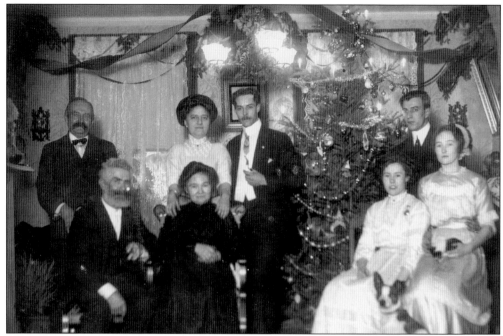

German immigrants brought their love of Christmas with them to New York City. The Christmas tree was the centerpiece of the German celebration of the Christmas holiday, and German American Christmas trees were often adorned by delicate handblown German glass ornaments (or perhaps American versions of them). They also were lit with real candles fastened into special clips. Here the Leyden family celebrates a festive Christmas, around 1912.

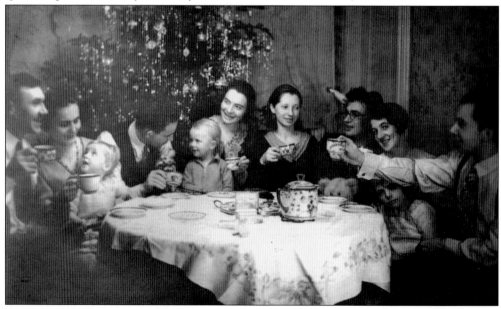

This photograph shows a group of German friends celebrating the New Year's Eve holiday in an apartment in Queens in December 1931. German celebrations of holidays such as Easter, Christmas, and New Year's Eve were festive occasions, with plenty of food and drink for everyone.

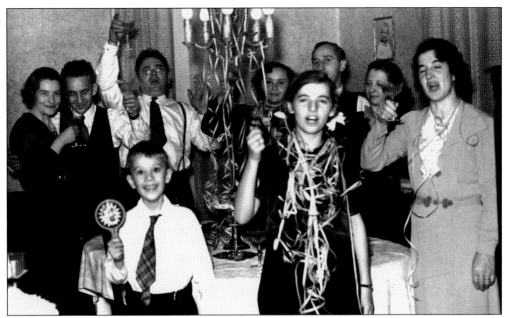

In this photograph, a group of German American New Yorkers celebrates with a cheery toast as 1936 turns to 1937. The celebration of Christmas as it is known today gained popularity during the mid-19th century after Queen Victoria of England married Prince Albert of Germany, who introduced some Christmas traditions to England, notably the decoration of a live tree inside the house.

One of the best-loved Christmas songs of today is "Silent Night," written by two Austrians, Franz Gruber and Joseph Mohr, in 1816. This version of the song was published in a German songbook used by a Lutheran school in Manhattan.

Am Oster Dienstag

den 25. April, 1905,

Abends 8 Uhr,

wird in der

Ev. Luth. Immanuels Kirche,

213 & 215 Ost 3. Strasse,

Das Leben Jesu

in herrlichen stereoptischen

Bildern

mit Erklärungen und Gesangvorträgen

gegeben werden.

———

Das Leben Jesu

in Bild, Wort und Gesang

ist eine ergreifende Predigt für Herz, Auge und Ohr. Niemand sollte unterlassen zu kommen.

Eintrittspreis für Erwachsene 25c, für Kinder in Begleitung ihrer Eltern oder erwachsener Geschwister 15c.

Tickets sind am genannten Abend von 7 Uhr an, oder am Abend vorher im Schulsaal zu haben.

Im Namen der Committeen

C. J. RENZ, Pastor,

213 E. 83. Str.

A flyer advertises a special Easter Sunday presentation called "The Life of Jesus," to be given on April 25, 1905, at the Immanuels Church on East 83rd Street. The admission price for this special occasion was 25¢ for adults and 15¢ for children.

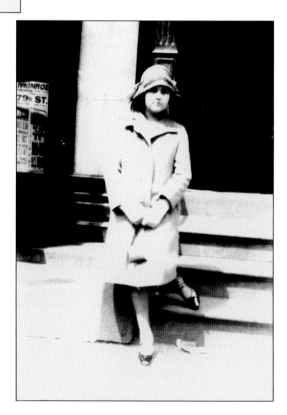

Margaret Leyden of Yorkville poses on Easter Sunday 1927, probably on her way to church. Easter has always been an important holiday to Germans, both Protestants and Catholics alike. Note the sign in the background for the Monroe Theatre on 79th Street.

The Trinity Lutheran Church in Middle Village was founded in 1863. Middle Village is one of the few remaining bastions of German culture in New York City and became especially popular during the 20th century. Adjacent to the attractive Juniper Valley Park, Middle Village is a peaceful neighborhood.

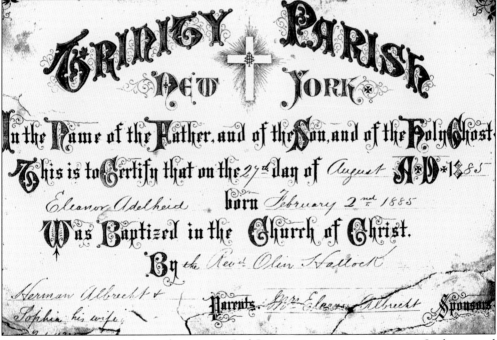

Eleanor Adelheid Albrecht was born in 1885 of German immigrant parents, one Lutheran and one Catholic. Her parents had her baptized in the Episcopal Trinity Church parish. In most small towns in Germany, either Lutheran, Roman Catholic, or sometimes both, were present. Once in New York City, there was a wide variety of religious choices available, and some Lutherans did make the switch to a different church.

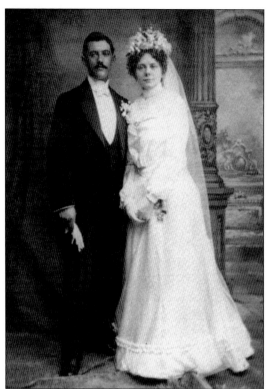

Children of German immigrants tended to marry within their own ethnic group. This trend continued well into the 20th century, until the German population spread out into the other boroughs and the suburbs of New York City. This photograph shows Yorkville groom George W. Voigt and his bride Emilie Baumann in 1900.

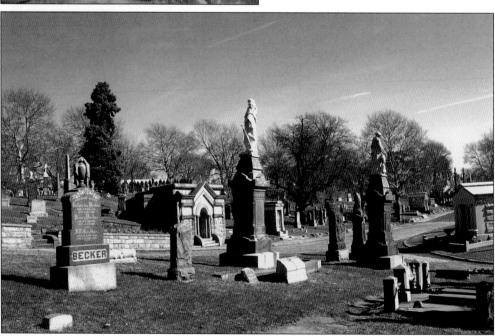

The Lutheran Cemetery (now the All Faiths Cemetery) in Middle Village, Queens, was founded in 1852 and contains the graves of thousands of German immigrants to New York City. Located on Metropolitan Avenue, the cemetery is the final resting place for many victims of the *General Slocum* disaster.

Deceased members of German immigrant families were likely buried across the river in Queens. By the time of the peak years of German immigration, several cemeteries had opened in Queens. One of the older cemeteries in the New York City area is St. Michael's in Astoria, Queens. Among those who are buried at St. Michael's is the famous musician Scott Joplin. Shown is a photograph of the gravestone of William F. Voigt taken during a visit by his family, around 1940. By the 1940s and 1950s, cemeteries even farther from the city, such as Pinelawn in Farmingdale, became the final resting places for German Americans.

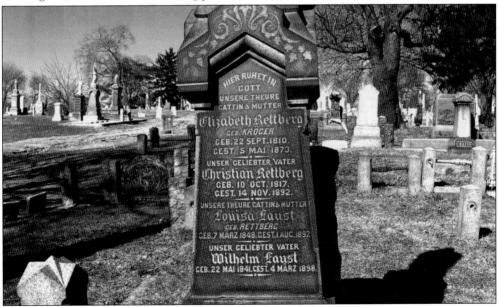

An elegant 19th-century monument for members of the Rettberg family is located in the picturesque Lutheran Cemetery in Middle Village, Queens. The immaculately kept cemetery has numerous beautiful monuments, statuary, and crypts of German New Yorkers.

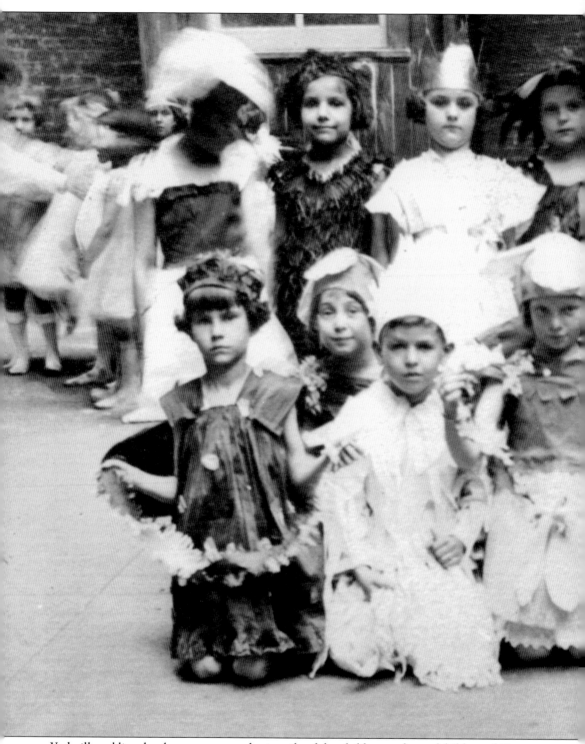

Yorkville public schools were composed primarily of the children and grandchildren of German immigrants, with a smattering of others from all over Europe but especially from eastern Europe, another group that settled in Yorkville. This photograph shows a Yorkville elementary school

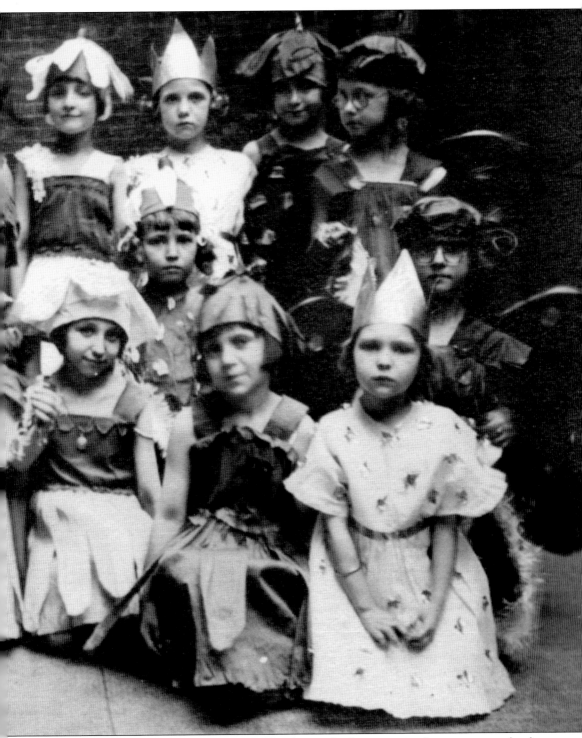

class of children in fanciful costumes, probably a first-grade class preparing for a party or a school play, in the yard of its school building around 1921.

Public School 96, located in Yorkville, educated countless hundreds of children of German immigrants. Shown here is an award certificate dated September 1901, given for good behavior and made out to Minnie Voigt, the daughter of German immigrants.

GERMAN-AMERICAN SCHOOL ASSOCIATION
DEUTSCH-AMERIKANISCHER SCHULVEREIN
New York, N. Y. 10028

ZEUGNIS

fuer _Anita Unfried_

Schuljahr _1975/76_ Schule _Ridgewood_ Klasse _2 c_

	Weih-nachten	Ostern	Schul-schluss
1. FUEHRUNG:			
Betragen	a	a	a
Fleiss	a	a	a
Aufmerksamkeit	a	a	a
2. LEISTUNGEN:			
Lesen	93	93	93
Schrift	—	—	—
Muendl. Ausdruck	92	92	92
Rechtschreiben	95	93	92
Sprachform (Grammatik)	88	86	88
Aufsatz	—	—	—
Erdkunde Deutschlands	—	—	—
Deutsche Literaturgeschichte	—	—	—
Deutsche Geschichte	—	—	—
Durchschnitt	92	91	91
3. SCHULBESUCH:			
Versaeumte Stunden— entschuldigt	—	I	—
Versaeumte Stunden-unentschuldigt	—	—	—
Verspaetungen	—	—	—

4. BEMERKUNGEN: _versetzt - 3. Klasse_
3. Preis : Bronzemedaille des Schulvereins

Schulleiter _____ anton arnold
 Lehrer

Unterschrift des Vaters oder Stellvertreters:
Weihnachten Ostern Schulschluss

I. Unfried Ignaz Unfried

The German-American School Association operated schools located at 207 East 84th Street in Manhattan and 70–01 Fresh Pond Road in Ridgewood. Shown here is Anita Unfried's report card for the 1975–1976 school year, with grades given by her teacher Anton Arnold.

***KIRIN, DOROTHY**
55 West 97th Street
Housekeeper 3; Personality
Rep. 4, 6, 7; S.S.S. 4.
She needs no advertisment.
We all know her golden hair
and her sun-kissed smile.

***KLEIN, MARGARET**
1235 York Avenue
Aide 5; Sec. 7, 8; Foyer Mar-
shall 6; Traffic Capt. 7, 8;
Gym Ass't 5; German Club 5;
Ticker Club 7.
She is poised, clever and ef-
ficient.

KIRSCHNER, DOROTHY
43-67 168th St., Flushing, L. I.
G. O. Rep. 7, 8; Sec. 3, 4;
Marshal 4, 5, 7; Tennis 6.
To know her is to love her
To hear her is to laugh.

KLETTER, PAULINE
1268 Olmstead Ave., Bronx
Marshal 5; Office Asst. 6, 8.
It's nice to be natural
When you're naturally nice.

*****KIRSCHNER, CORNELIA**
312 East 83rd Street
Marshal 5; Aide 6; Treas. 7,
8; Ticker Club 7, 8; Bazaar 6.
She's as bright as she is fair
A girl with charm so great is
rare.

KOCH, MARIE
539 East 134th Street
Marshal 4; Secretary 4, 7; Stu-
dy Hall Squad 5, 7.
Here's a girl, who as a rule,
Really loves to go to school,
(?)
Will someone please tell her,
I pray
Why we can't have Sunday
every day.

KLEIN, EVELYN
1052 Teller Ave., Bronx
Marshal 4, 5; Office Assistant
8.
Her conversation never lags
For she always has something
exciting to say.

KOLOKOWSKI, HELEN
2375 36th St., Astoria, L. I.
A loyal, devoted friend.

KLEIN, FRIEDA
203 East 175th Street
Marshal 6, 7, 8.
The possessor of a captivating
smile.

KOMAREK, MARY
310 East 73rd Street
Bank Rep. 1, 2, 3, 4; Office
Aide 7, 8; Sec. 8.
They say silence is golden
and if this is true,
Mary must have a million or
two.

KLEIN, JEANNETTE
446 East 78th Street
A lass of quiet dignity
Who's neat and accurate as
can be.

KOPIT, LILLIAN
346 East 76th Street
In her silent way,
She progresses day by day.

The Spotlight ● **Page Thirty-three**

Julia Richman High School, located at 68th Street and Second Avenue, was a few blocks south of Yorkville but attracted girls from around the entire city. On this yearbook page from 1932, one can see four seniors from the Yorkville area. As is evident here, Yorkville also was popular with eastern European immigrants.

This New York City public school homemaking activity handbook from 1924 shows two associate superintendents of German descent—Edward W. Stitt and Gustave Straubenmüller. Intermediate School 164 was later named after Stitt, and Junior High School 72 was named after Straubenmüller, who was the author of several publications, including a book called *A Home Geography of New York City* and articles on art museums and industrial education.

Five

FOOD AND DRINK

To those who grew up eating German food, the smell of simmering sauerbraten or pot roast brings back fond memories. German food is a celebration of hearty flavors and mouthwatering sauces. When Germans came to New York City by the thousands during the 19th century, they brought with them their love of food and drink. First in the Kleindeutschland neighborhood downtown and then in Yorkville on the Upper East Side, German immigrants opened countless butcher shops, grocery stores, restaurants, and saloons/beer gardens. A rich variety of sausages, ham, bacon, pork, veal, and beef cuts and preparations were offered for sale. Indeed it was Germans who were responsible for two of America's favorite foods, the hot dog and the hamburger. They were also responsible for encouraging America's love of condiments. Mustard, ketchup, horseradish, and pickles were bottled by a number of New York City companies. Then there was beer—German breweries could be found all over the city. After a hearty German meal came a rich dessert. German bakeries were once common around New York City, offering everything from pumpernickel bread to Black Forest cakes to doughnuts. Although much of the German food of New York City has since vanished, German food lives on in the few remaining establishments and in the recipes lovingly handed down from the immigrant generation to their descendants.

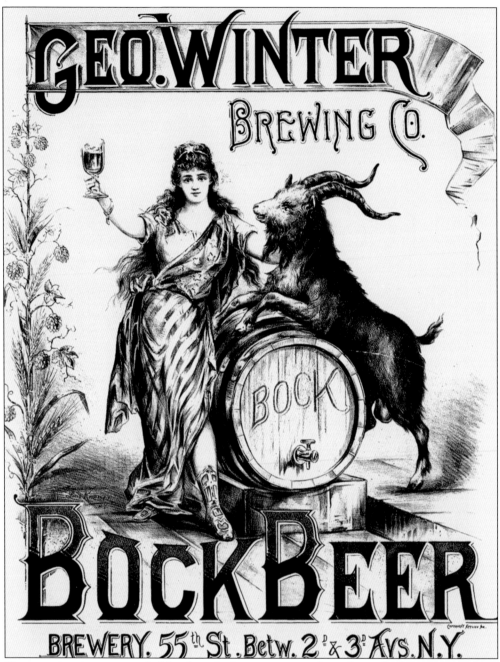

Germans immigrants, much like their Irish counterparts, brought with them to New York City their love of beer. One of the Germans' contributions to New York City and elsewhere in the country (especially the Midwest) was their breweries. This advertisement is for bock beer produced by the George Winter Brewing Company on 55th Street in Manhattan, around the late 19th century. Some of the 20th-century German beers that were brewed in New York City include Schlitz, Piels, Krueger, and Rheingold.

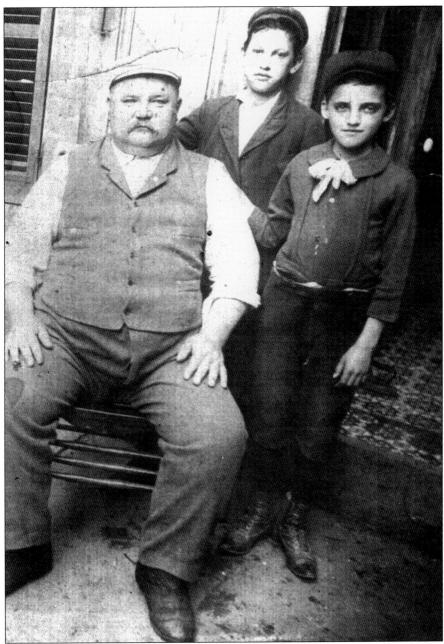

Carl Friedrich Voigt, born in 1848, came to New York City from Eisenberg, Saxony, in 1866. He originally lived on the Bowery but later moved to Yorkville and founded a pickle works there, on East 78th Street. Although the factory made and bottled pickled beets and mussels, their specialty was horseradish. He is shown here in about 1892, with young sons Jacob and William, both of whom worked for the family business. The horseradish root was ground by hand, prepared from a special recipe, and bottled, and then the condiments were loaded onto a horse-drawn cart and delivered to saloons and hotels around the neighborhood. After Carl's death in 1906, his sons carried on the business. Sometime around 1920, Best Foods offered to buy the Voigts out, but the deal fell through, and the business was finished.

The 86th Street Brauhaus was a popular German restaurant of the 1950s and 1960s, located at 249 East 86th Street. The interior was decorated in the same fashion as the exterior, and the menu included many traditional German favorites.

German American Rathskeller at 17th Street and 3rd Avenue

Yorkville was not the only location where one could obtain fine German cuisine in Manhattan. The German American Rathskeller, also known as Joe King's German American Rathskeller (and formerly Scheffel Halle), was located at 17th Street and Third Avenue. Two thousand framed photographs lined the walls of this cozy establishment, originally founded in 1879. Among the German favorites served here were schnitzel, pigs' knuckles, and apple strudel.

Lüchow's Restaurant, located at 110–112 East 14th Street, was founded in 1882 by August Lüchow, a former waiter. It was a popular dining spot for many years. There was even the *Lüchow's German Cookbook* by Jan Mitchell, published in the 1952. By the 1950s, there were seven dining rooms, including the Hunting Room and the Niebelungen Room. Lüchow's closed in 1982, and a fire destroyed the building in 1992.

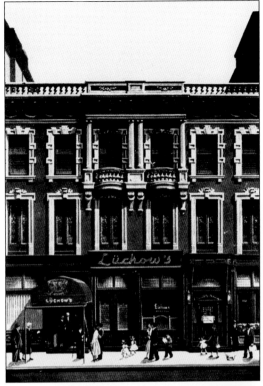

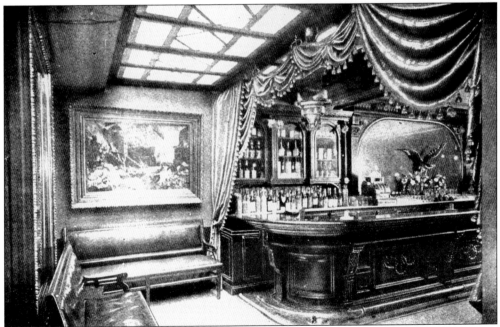

Freibel and Lang's City Hall Rathskeller was located at Broadway Avenue and Chambers Street during the early 20th century. A German-language guidebook of the time called it "Einer der beliebtesten Restaurationen der unteren Stadt." Rathskellers and beer gardens were popular spots until World War II, after which a decline in the number of such establishments began.

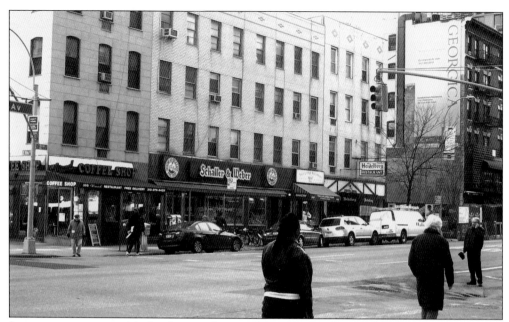

In more recent years, with the closing of many of the old-time German butchers, two stores have been the most popular sources of German groceries for New Yorkers—Schaller and Weber and Karl Ehmer. Schaller and Weber is located on Second Avenue at 86th Street, while Karl Ehmer is headquartered in Ridgewood. The two shops offer a wide variety of German meats, as well as a large selection of chocolate and candy, imported cookies, fresh cheeses, bread, and packaged foods such as applesauce and pickles imported from Germany. At the far right of this photograph is the Heidelberg Restaurant, the last of Yorkville's famous German eateries that were once plentiful on the Upper East Side.

Ferdinand Schaller (1904–1994) was the cofounder of Schaller and Weber, along with Tony Weber. Raised in a family of plasterers, Schaller decided to become a butcher at an early age. By 14, he was an apprentice butcher in Neuhausen, near Stuttgart. He arrived in the United States in 1927 and opened the first store in 1937.

Here is an attractive view of the Schaller and Weber store window on Second Avenue, around the 1940s. Such displays were common in Yorkville, and for many a German resident, the mouthwatering meats and baked goods in store windows were all the advertising that was needed.

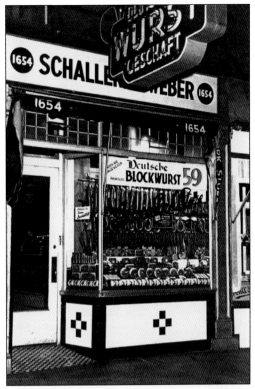

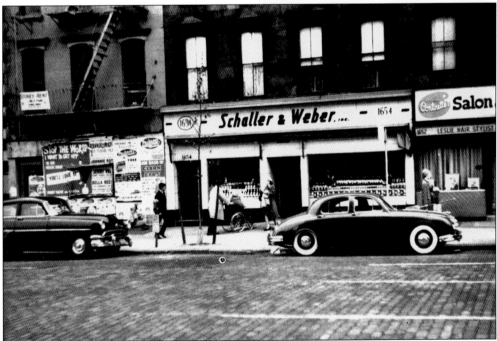

This photograph shows a view of the east side of Second Avenue, between 85th and 86th Streets, during the 1950s. Schaller and Weber, at number 1654, had expanded in width by this time and was thriving in what was at the time still predominantly a German neighborhood.

Ferdinand Schaller poses in the main Schaller and Weber store on Second Avenue in Yorkville during the early 1960s. By this time, the business had grown considerably, and there were several retail locations in New York City and Long Island, including Ridgewood, Flushing, Astoria, Jackson Heights, Floral Park, Franklin Square, and Northport.

Bill Schaller (right), son of the founder, and others work in the Astoria factory of Schaller and Weber preparing bacon around 1987. The pork meat would then be smoked in the company's on-premises smokehouses before being prepared for sale in the store. Improvements in packaging equipment during the 1980s enabled the business to expand its reach and offer vacuum-sealed goods to retailers all over the country.

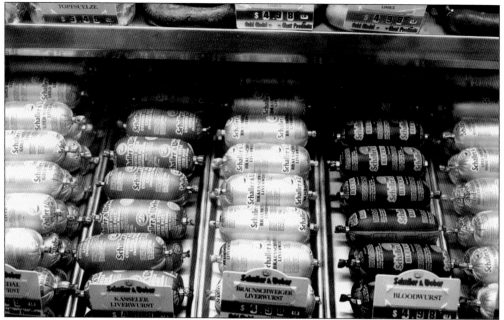

A variety of sausages and wursts are on display in the Schaller and Weber store on Second Avenue. It is amazing to think just how many varieties of liverwurst there are, including Gold Medal, Kasseler, and Braunschweiger. Each one is made with slightly different ingredients, but the end result is the same—a uniquely German product that has been enjoyed by countless thousands of customers.

Joseph Horn and Frank Hardart opened their first restaurant in the late 19th century in Philadelphia, but in 1902, they opened a new type of restaurant. Called an Automat, it was a new concept in food service. The restaurant featured self-service dining, with a selection of sandwiches and prepared dishes behind glass, accessible when the customer deposited money. The first Automat in New York City opened in 1912 on Broadway and 13th Street. By the 1930s, there were a number of Automats in the city. The last of the Horn and Hardart restaurants closed in 1991. This photograph shows a Horn and Hardart advertisement that still exists on a West 38th Street building, off Seventh Avenue.

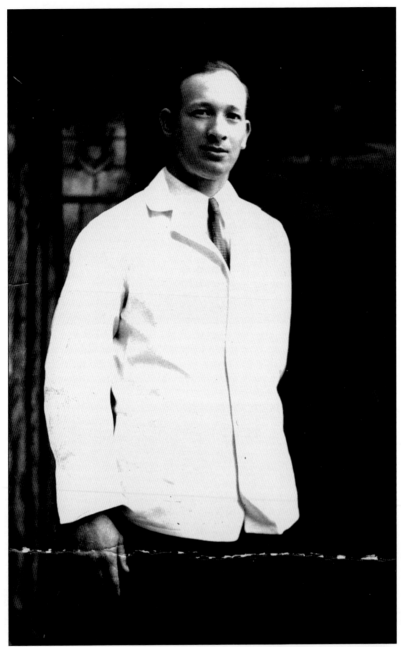

A young butcher named Herman Albrecht, dressed in a fresh white coat, poses for the camera in the 1920s. He worked in a butcher shop on 82nd Street near Third Avenue in Yorkville for many years. Many German immigrants were butchers, an occupation that tended to run in families or sometimes was more prevalent in certain German towns. The demand for sausage (bratwurst, weisswurst, bockwurst, and knackwurst, to name a few) and special cuts of meat was high among German American families in New York City. As the 20th century progressed, the traditional German butcher shop vanished for two main reasons: first, supermarkets became more popular, and second, descendants of German immigrants left New York City for the suburbs or other parts of the country.

The Bauer's Bake Shop, located on Dry Harbor Road in Middle Village, was founded in the 1930s. At one time there were at least three German bakeries in the city by that name; the one located on Queens Boulevard in Elmhurst was popular through the 1970s and early 1980s. German bakeries in the New York City metropolitan area have been decreasing in numbers in recent years, as demand has decreased.

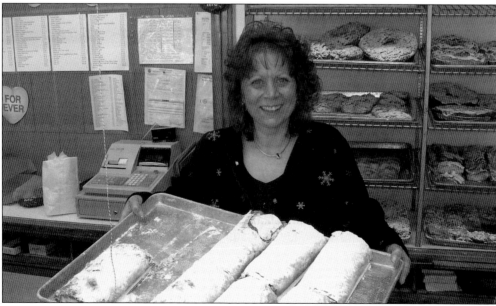

Anita Wunsch of the Bauer's Bake Shop in Middle Village shows off some freshly baked strudel. Germans and Austrians are known for a wide variety of pastries and treats, including turnovers, doughnuts, danishes and buns, Black Forest cake, linzer tarts, Sacher tortes, and *lebkuchen* (spice cookies). Among German packaged goods available in New York City, the Entenmann's and Friehoffer's brands are popular. One of the top brands of imported German cookies is Bahlsen.

New Yorkers of German, Austrian, Swiss, and Hungarian descent all enjoy many of the same type of pastries and cakes because of the far reach of the Austro-Hungarian Empire, and the proximity of Vienna to Budapest. Here a family of Hungarian and German descent enjoys homemade *kugelhopf*, or bundt cake, with chocolate chips and nuts at a family gathering during the early 1970s.

The New York City–born daughter of German immigrants wrote down this recipe for caraway cookies during the 1940s. Caraway seeds were a popular German flavoring. Germans were known for their cuisine, and many German New Yorkers were expert cooks. In both Kleindeutschland and Yorkville, there were plenty of butchers and grocers to supply the ingredients for any German specialty.

Caraway Cookies

1/2 cup shortening
1 cup sugar
1 egg
1/4 cup milk
1 1/2 teasp. caraway suds
2 cups flour
1/2 teasp. salt
2 " baking powder

Some German Americans relied upon their own "touch" for cooking; others used old family recipes or found recipes for German favorites in newspapers. This recipe for *Dresdner stollen* (a sweet bread popular at Christmas) was clipped from a newspaper probably during the 1930s or 1940s and saved for many years.

Dresdner Stolle.

INGREDIENTS:
 2 yeast cakes
 ½ cup sugar
 1 cup of milk
 1 pound of flour
 ¼ pound of outter
 3 eggs
 3 tablespoons rose water
 ¾ cup seedless raisins
 1 heaping cup of currants
 1-3 cup chopped citron
 ½ cup chopped almonds
 ¼ teaspoon salt
 Slight pinch of cinnamon.

METHOD: Place the yeast cake and one-half tablespoon of sugar in a cup. Heat the cup of milk until lukewarm. Then take enough milk from the cup to dissolve the yeast and sugar. Add some flour and beat until smooth. Cover with a towel and let rise in warm place. Then cream the butter, sugar and eggs. Add the rest of the flour, the yeast mixture which has risen well, the rest of the cup of milk and the rose water. Mix well and turn onto kneading board. Then knead lightly but quickly until dough has risen well, add the raisins, currants, citron, almonds, salt and cinnamon. Roll out two inches thick, place on a pan and turn over one-third to form a long loaf. Let this mixture rise again for a good twenty minutes, brush the top with melted butter. Bake in a moderately hot oven. It will take about fifty minutes. depending on your oven. When the cake is still hot ice over the top with plain frosting.

NIEDERSTEIN'S
RESTAURANT AND CATERING
69-16 Metropolitan Avenue, Middle Village, N.Y. 11379 — Tel. (718) 326-0717

Niederstein's Restaurant was a fixture on Metropolitan Avenue in Middle Village for 150 years. Opened in 1854, the restaurant finally closed in May 2005. The last owners, who took over in 1969, were named Reiner and Herink. Its location directly across from the Lutheran Cemetery was a big reason for its popularity. As in many German restaurants, one of the most popular dishes was sauerbraten, along with roast loin of pork. There are only a few German restaurants left in the metropolitan area, including the popular Koenig's in Floral Park (Nassau County), just over the Queens border. The advertisement shown here dates to 1988.

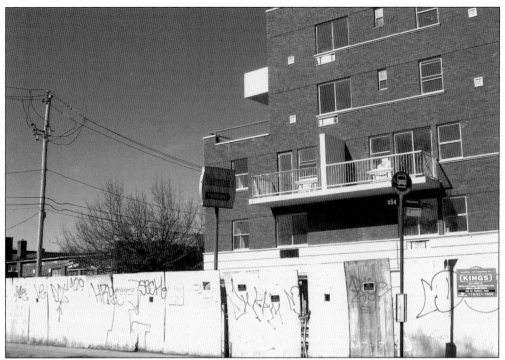

The only reminder of the legendary Niederstein's Restaurant in present-day Middle Village is a parking sign along Metropolitan Avenue.

Caren Prommersberger prepares the German dish called *rouladen* according to a recipe given to her by her grandmother, who arrived in New York City from Nurnberg in 1928. The key ingredients are beef, bacon, onions, mustard, and often pickles.

Six

CULTURE AND RECREATION

German culture and traditions thrived for decades, especially in the Kleindeutschland and Yorkville neighborhoods. Indeed, New York City in the early 20th century was alive with German culture. The German community celebrated life in many ways, from fraternizing to singing to shooting to picnicking. German New Yorkers could choose from a number of German newspapers, could patronize German businesses and eateries, and could find recreation just a stone's throw away from their homes. Even if the old German neighborhoods of New York have lost much of their German flavor, German heritage still lives on in each person with German blood in their veins. It lives in the old traditions that are kept alive and in the stories passed down from generation to generation.

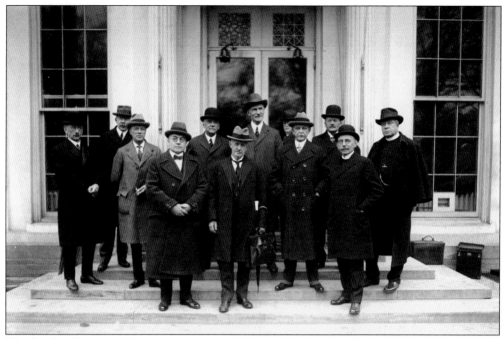

The Steuben Society of America is a fraternal society that was founded in 1919 and named after the German Revolutionary War hero Baron von Steuben. It is currently headquartered on Fresh Pond Road in Ridgewood, Queens. This photograph shows leading members of the Steuben Society in 1923.

Thirty-First Annual
Steuben Parade Dinner

FRIDAY, SEPTEMBER 16, 1988

at the
GRAND BALLROOM
HOTEL ROOSEVELT
45th Street at Madison Avenue
New York City

Reception and Cocktail Hour 8:00 P.M.
at the Terrace Suite
Music by : The Hannoverschen Jagdhornbläser
Dinner Grand Ballroom 9:00 P.M.
Dancing Thereafter

The Steuben Day parade is the biggest German-related celebration in New York City, outside of any Oktoberfest activities that may occur in various places. Shown here is the cover of the program for the 1988 Steuben Day parade dinner at the Hotel Roosevelt, with an image of Baron von Steuben at top left.

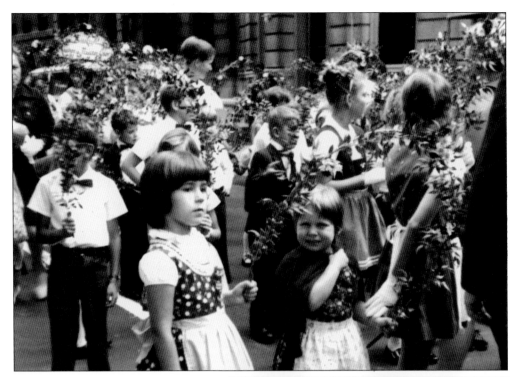

The Steuben Day parade has been an annual fixture on the streets of Manhattan every fall since 1957. This celebration of German culture in New York City is a recognition of the many thousands of New Yorkers who still actively retain and promote their German heritage. For the 50th anniversary parade in 2007, Dr. Henry Kissinger was the grand marshal and former German chancellor Helmut Kohl was the guest of honor. Each year, a new Miss German America is crowned and serves as queen of the parade. These photographs show two scenes from Steuben Day parades of the 1970s. Above, Anita Unfried (front center) marches in the 1970 parade, and below is a scene from the 1973 parade.

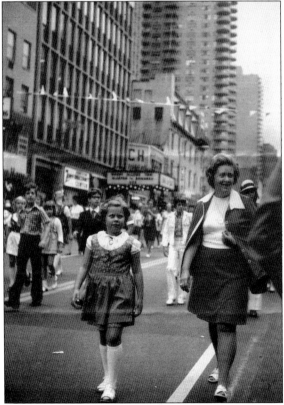

With the advent of the phonograph in the late 19th century, the major record labels began to release German opera and folk music, understanding that there was quite a substantial market for such ethnic music in places such as New York City. The 78-rpm record shown on this page was released by the Odeon Company around 1910. The numbered label likely refers to a dealer cataloging system. For those who could afford player pianos, piano rolls of German songs were also readily available. The machine-punched holes in the roll of paper were the code for which notes the piano hammers should strike. The "Auf Wiedersehn" tune shown here was released on the Melodee label around 1910. Another popular piano roll company that published German popular and folk music was QRS, founded in 1900 and still in business today.

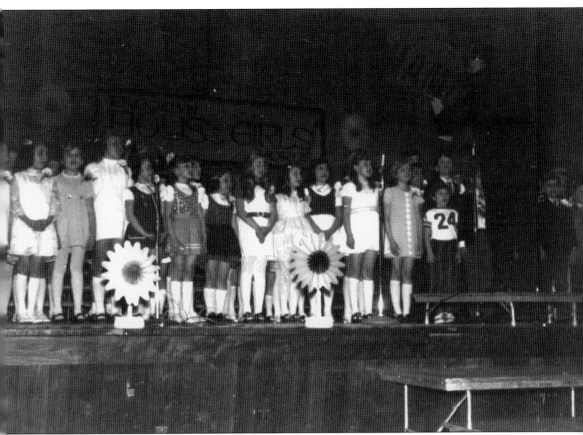

The Brooklyn Boys and Girls Chorus was founded in 1906. For some years, it was led by Joseph Hellinghausen. For the occasion of its 50th anniversary, it gave a concert at the Brooklyn Academy of Music. Singing was a very common pastime and indeed a passion among Germans in New York. There were numerous other German choral societies in the city; in 1894, there was a special parade of German singers in the city in advance of a singing contest. In 1921 in Brooklyn alone, one could also find the Hessischer Saengerbund (founded in 1876) on Onderdonk Avenue, the Jungen Maennerchor (founded in 1913) on Wyckoff Avenue, the Adler Maennerchor (founded in 1872) on Fulton Street, the Katolischer Maennerchor (founded in 1911) on Wilson Avenue, and the Schweitzer Damenchor (founded in 1902) on Putnam Avenue. This 1972 photograph shows the Brooklyn Boys and Girls Chorus singing in a springtime concert.

Ernst Kaufmann,

Psalterbuch für die christliche Jugend.

New York. Chicago.

A songbook by Ernst Kaufmann, around 1900, featured songs in both German (the majority) and English. The book sold for 40¢ a copy or $4 a dozen and was used by Germans in New York and elsewhere. The songs in the book are for all Christian occasions, including Christmas, Epiphany, and Easter. Kaufmann also wrote a book in English called the *Sunday School Hymnal*.

Liederkranz Hall, seen here in 1909, was located on 58th Street between Park and Madison Avenues. The Liederkranz Society was founded in 1847 as a musical and cultural organization. Piano maker William Steinway was the president for many years. In 1918, former president Theodore Roosevelt gave a speech there about the ongoing war (World War I) where he told the audience, "Our whole effort must be to bring Germany to her knees."

The Arion Society was also a popular New York City musical and cultural organization. It was headquartered in a stately building (seen here in 1909) at Park Avenue and 59th Street and was founded in 1854 by former members of the Liederkranz Society.

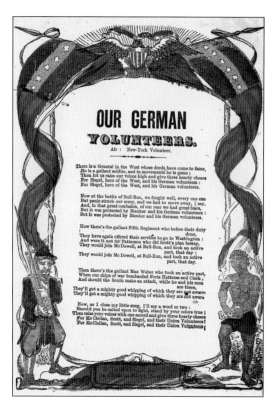

The German community in New York City rallied to the support of the Union's efforts to defeat the rebels during the Civil War. A German named Col. Louis Blenker led the "German Volunteers" in battle. Unfortunately Colonel Blenker died from injuries he sustained after he fell from his horse in 1863. Two different versions of a Civil War–era song about the famous German Volunteers are shown on this page.

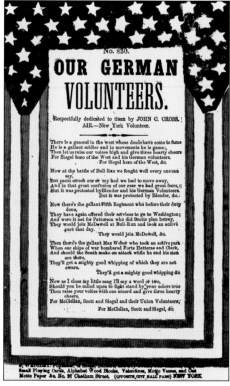

New York City schoolchildren perform a German dance at a meeting of the Playground Association in the early 20th century. Germany actually consists of numerous regions, each with its own distinct culture and traditions—Bavaria, Odenwald, Thuringia, for example. Once in New York City, Germans from all regions were simply known as German, and the food and culture of the entire land was seen as German.

This photograph taken during a masquerade ball at the Gottscheer Hall in Ridgewood in 1955 shows Herta Tscherne on the left and Irma Jonke to the right. Gottscheer Hall, also known as Gottscheer Clubhouse, was built in 1924. Over the years, it has served as a meeting place and concert hall and has hosted many dinners and dances. It was named after the region in present-day Slovenia where many of the 20th-century German immigrants to Queens came from.

Founded in 1891, the East Side Settlement House was located at 540 East 76th Street (at East End Avenue near the East River). It was a popular spot for gymnastics, basketball, and other sports. It also offered nursery and kindergarten classes, music school, and summer camps. It offered placement services as well, finding employment for boys who were in need of a job. Because of its convenient Yorkville locale, many German American teenagers frequented the facility. It was a way for them to get some exercise and participate in organized sports. Of course, there were also plenty of pickup games of stickball and other sports in the streets of Yorkville. Shown here are the East Side Settlement House basketball team from 1918 and the gymnastics team from about the same time. The actor James Cagney is said to have participated in activities at the settlement house.

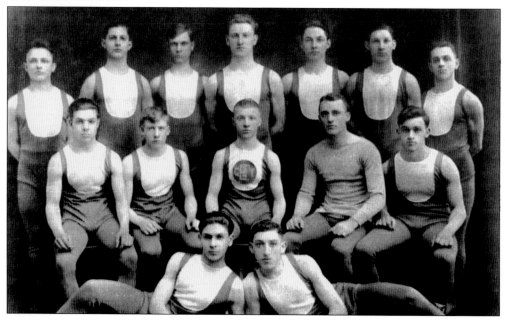

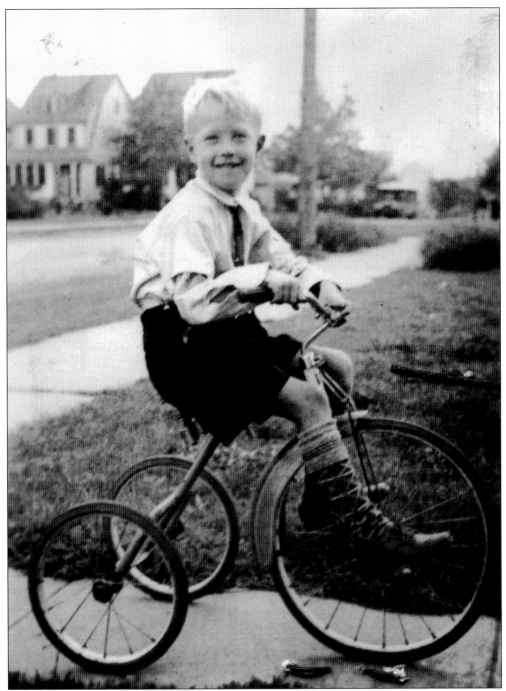

Although German American children living in Manhattan had ample opportunities for sports and recreation, those German Americans who lived in the outer boroughs could enjoy even more sporting activities, including organized baseball, football, and soccer games as opposed to pickup stickball games in the middle of a Yorkville street. The "suburbs" offered less-crowded streets and sidewalks as well as more fields and parks, and many homes even had backyards and front lawns. Here young Peter Prommersberger rides his tricycle in Queens, around 1935.

This page shows advertisements for various amusements in a 1903 *Staats-Zeitung* newspaper. Among the many offerings were steamboats to Coney Island, trips to Glen Island, a concert at Terrace Garden on 58th Street, and a concert and vaudeville show at the Atlantic Garden on the Bowery.

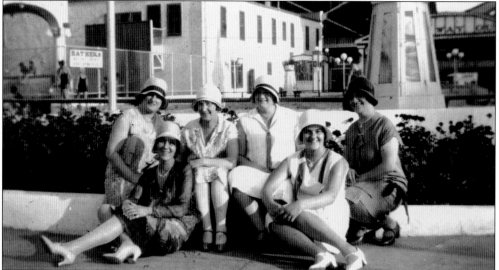

The Coney Island amusement park complex in Brooklyn was a popular early-20th-century destination for kids of all ages. A subway ride took Manhattan Germans there in about an hour's time. These teenagers, probably from Yorkville, enjoy the amusements on a warm summer day in 1930.

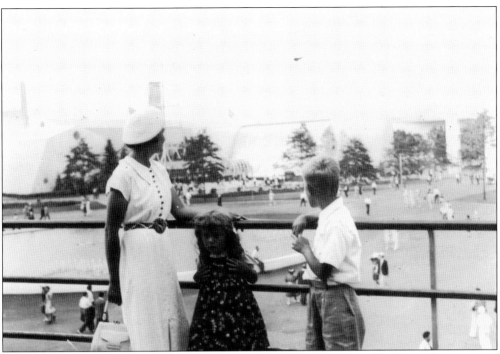

The world's fair of 1939–1940 in Flushing Meadow Park, Queens, offered a wide variety of amusements and exhibits. In this photograph, the Prommersberger family looks out toward the fairgrounds on a pleasant summer day.

FREE·CLASSES for ADULTS

SOCIAL STUDIES
·
HOME-MAKING
·
BUSINESS
·
MUSIC

SCHOOL·FOR·ADULT·EDUCATION
KNOWLEDGE IS POWER

AMERICANIZATION
·
LANGUAGE
·
SCIENCE
·
ARTS

CALL OR WRITE
LESLIE E BROWN, DIRECTOR
SAUNDERS TRADES SCHOOL
YONKERS, N.Y.

REGISTER NOW
THE HIGH SCHOOL of COMMERCE
NORTH BROADWAY
YONKERS, N.Y.

SPONSORED BY
NY STATE EDUCATION DEPT.
AND WORKS PROGRESS
ADMINISTRATION

After World War I, there was an increased focus on Americanizing the ethnic Germans in New York City and elsewhere in the country. This was the beginning of a process that led to the decline of Yorkville and German culture in general. Germans who came to New York City as adults in the 20th century had many opportunities to become Americanized and learn English. Classes such as the ones advertised in this 1930s WPA poster were popular with new arrivals and helped ease the path toward citizenship.

Although immigrants often tended to be unfairly stereotyped in the public mind, depending on their country of origin, some stereotypes might have had some truth to them. The image of Germans as industrious and hardworking seems to be quite true. But though German immigrants worked quite hard, they also took their recreation very seriously. Among women, knitting, crocheting, and painting were popular pastimes. Among men, craftsmanship was common. In his spare time, Ernest Leyden of the Bronx built a pleasure boat completely by hand. In the photograph above, Leyden (center) stands in front of the framework of his boat-to-be. Months later, a proud Leyden (standing in front) appears with family and friends at the boat's berth at Clason Point in the Bronx about 1910. Boating was a pleasant pastime that was more popular before the industrialization of much of the city's waterfront occurred.

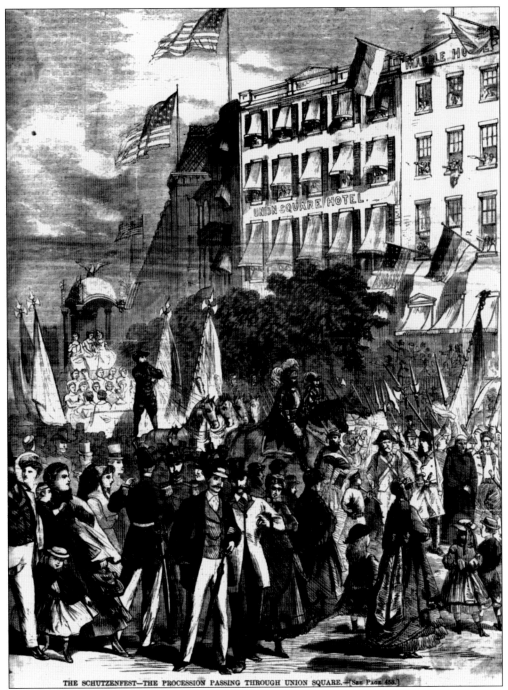

THE SCHUTZENFEST—THE PROCESSION PASSING THROUGH UNION SQUARE.—[See Page 453.]

German Americans in New York were proud of their heritage, and they often joined societies and clubs where they could fraternize with other German Americans. Shooting was a popular hobby among German men, and so a common group in New York City was the Schutzengild, a sharpshooting club. In this engraving from an 1868 newspaper, a Schutzenfest celebration is shown marching through Union Square. Their end destination would likely be a park where they could hold a shooting contest and award prizes to the top contenders.

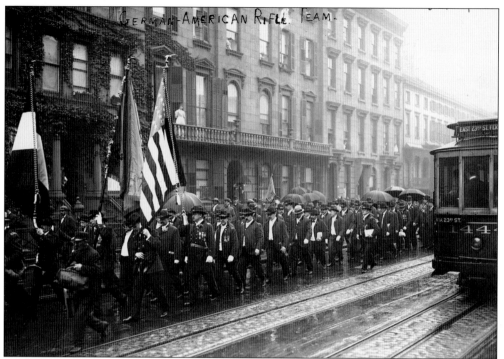

This photograph shows the "German-American Rifle Team" on parade down 23rd Street in Manhattan in 1909. The popularity of the sharpshooting clubs faded in the days after World War I and declined further by the end of World War II.

Two German American couples from New York City enjoy an open-air lunch in May 1928. Perhaps a liverwurst sandwich and some refreshments could be enjoyed on a fine spring day.

The biggest disaster ever faced by the German community of New York City was the tragic burning of the steamboat *General Slocum*. Chartered by the St. Mark's Church on the Lower East Side of Manhattan to take parishioners to a picnic on Eatons Neck, Long Island, the boat left Manhattan on the morning of June 15, 1904. Not long after, a horrendous fire started on board. Once the fire spread, it did not take long for the ship to burn to the waterline. About 1,100 of the 1,300 mainly German passengers died that morning, including many women and children. The shocking headlines from the June 15, 1904, evening edition of the *World* newspaper called out some of the particulars of the tragedy.

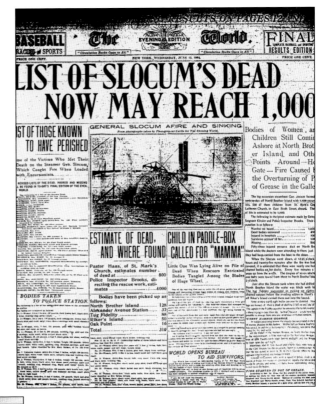

Many of the victims of the *General Slocum* disaster were buried in the Lutheran Cemetery in Middle Village, Queens, where a memorial monument to the dead was soon erected. Several people were awarded medals by the United States Life-Saving Service for their bravery, including a bricklayer who assisted in a rowboat, and a 15-year-old girl recovering from scarlet fever at a hospital on a nearby island, who rescued nine children. Shown here is the certificate of enrollment for the *General Slocum*, which was built in 1891 and had been recently inspected. The disaster spelled the end of the German community of Kleindeutschland; the rest of the downtown German-population neighborhood moved to Yorkville to move past their grief; nearly every family had a friend or relative who had been killed in the fire.

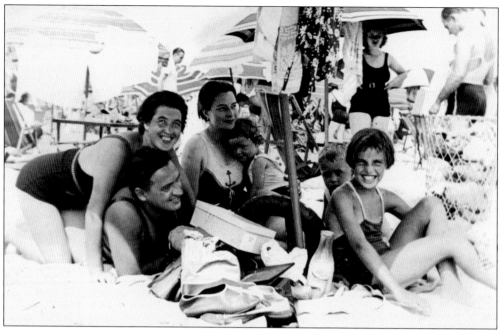

Jones Beach was a wonderful place to German immigrants. Coming from a mostly landlocked country, many immigrants and their children greatly enjoyed their new proximity to the ocean, and once Jones Beach opened in 1929, they were happy to spend the day there. It also offered a welcome respite from the hot city streets of New York City in the summer.

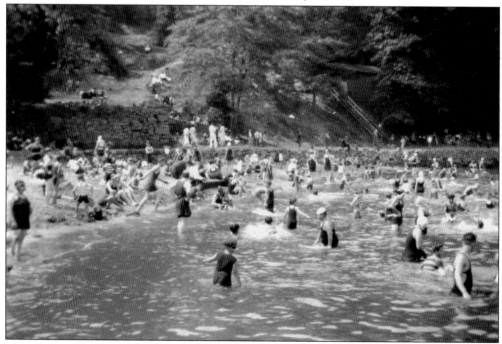

There were more places for New Yorkers to take a refreshing swim back in the late 19th and early 20th centuries. The waters around the boroughs were cleaner then. This photograph shows swimmers enjoying a dip during the 1920s, probably in the Bronx.

German American children of the early 20th century typically grew up with the same types of old-fashioned wooden toys and stuffed animals that were very common in Germany, given to them by Santa Claus on Christmas or perhaps by their parents for birthdays. In fact, Germany has been known as one of the world's premier toy makers for hundreds of years. This photograph dates to 1931 and shows a selection of Christmas presents given to a young German American in New York City.

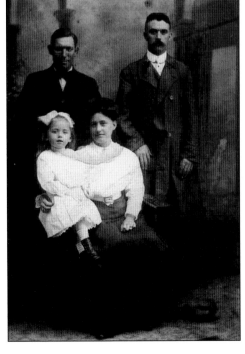

Recreation could be had throughout the five boroughs of the city, but for those who could afford the transportation farther, other locales also offered amusement. This photograph shows some Yorkville residents at the Morris and Van Tine Studio in the West End neighborhood of Long Branch, New Jersey, on July 12, 1910.

Among the newspaper choices for German speakers were the *New Yorker Herold Evening News,* the *New Yorker Zeitung* (also known as the *Gross-New-Yorker Zeitung*), a morning newspaper, and the Sundays-only *New Yorker Revue*. These newspapers claimed to have more than 250,000 daily readers. The New Yorker Herold building was located on William Street near Park Row. This advertisement proclaims that the *New Yorker Herold* and *New Yorker Zeitung* use the same news sources as the big English newspapers: the *Times, World,* and *Tribune.*

Shown here is the cover of the *Gross-New-Yorker Zeitung* in September 1903. A variety of articles vie for the reader's attention, including a catastrophe on the Hudson River and an explosion at Ruppert's Brewery, as well as news from Bulgaria, Vienna, and St. Louis.

The German community in New York City had a large number of daily and weekly German-language publications to choose from. This is one called *Deutsch-Amerika*, which began printing in 1915 and was published every Wednesday by the *New Yorker Staats-Zeitung*. The publication was aimed at politically savvy readers who wanted to read detailed coverage about current events in Germany. Shown in this image is the first issue of 1920, price 10¢.

German Americans often kept mementos of their childhoods in New York City. This miniature tea set was given to Louise Bach shortly after her birth in 1902. She displayed it lovingly in her summer cottage on Long Island more than 90 years later.

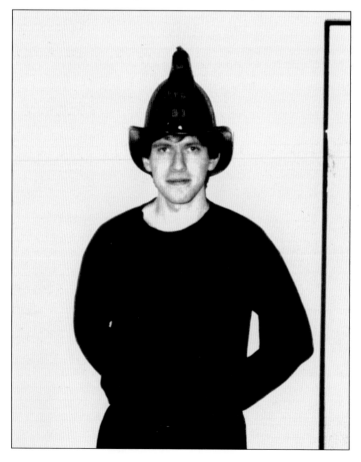

In this photograph from 1993, the author wears the fire hat of his great-grandfather, dating to the early 1900s. The hat was passed down to one cousin while the Knights of Pythias sword of the author's great-great-grandfather was passed down to another cousin. As the years pass and the first and second generations of German Americans die, the few remaining possessions from their Yorkville days get dispersed to descendants living in all corners of the country.

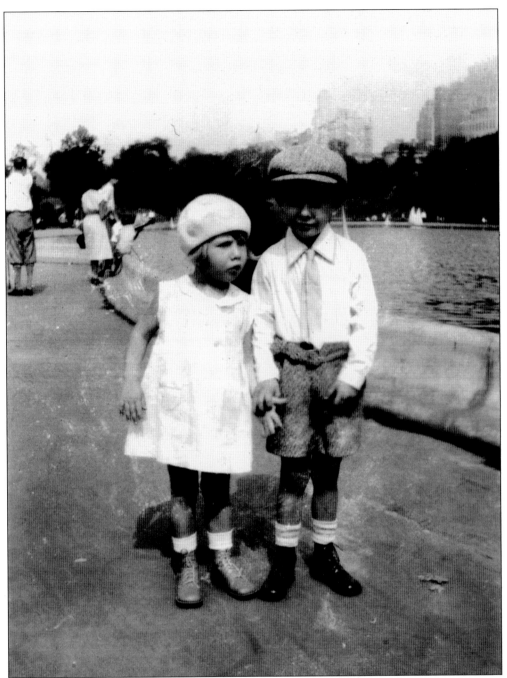

Jean and Al Albrecht pose near a lake in Central Park in about 1930. Young German American children would be accompanied to the park by their parents; as they got a little older, children would venture into the park on their own, if they were not at school or working. Some parents imposed curfews on their children but otherwise did not track their whereabouts. Many Yorkville kids played in the street or either Carl Schurz Park or Central Park. Those who grew up in Yorkville still retain fond childhood memories of that uniquely German place, no matter where they live now.

BIBLIOGRAPHY

Croscup, George E. *United States History with Synchronic Charts, Maps and Statistical Diagrams.* New York: Cambridge Book Corporation, 1915.

Faust, Albert Bernhardt. *The German Element in the United States.* Boston: Houghton Mifflin Company, 1909.

Furer, Howard B. *The Germans in America, 1607–1970.* Dobbs Ferry, NY: Oceana Publications, Inc., 1973.

Lyman, Susan Elizabeth. *The Story of New York.* New York: Crown Publishers, 1975.

Schoener, Allon. *New York: An Illustrated History of the People.* New York: W. W. Norton and Company, 1998.

INDEX

www.arcadiapublishing.com

Discover books about the town where you grew up, the cities where your friends and families live, the town where your parents met, or even that retirement spot you've been dreaming about. Our Web site provides history lovers with exclusive deals, advanced notification about new titles, e-mail alerts of author events, and much more.

MADE IN THE

Arcadia Publishing, the leading local history publisher in the United States, is committed to making history accessible and meaningful through publishing books that celebrate and preserve the heritage of America's people and places. Consistent with our mission to preserve history on a local level, this book was printed in South Carolina on American-made paper and manufactured entirely in the United States.

This book carries the accredited Forest Stewardship Council (FSC) label and is printed on 100 percent FSC-certified paper. Products carrying the FSC label are independently certified to assure consumers that they come from forests that are managed to meet the social, economic, and ecological needs of present and future generations.

FSC

Mixed Sources
Product group from well-managed forests and other controlled sources

Cert no. SW-COC-001530
www.fsc.org
© 1996 Forest Stewardship Council

Find Your Place in History.